The Inspiration of Landscape

ARTISTS IN NATIONAL PARKS

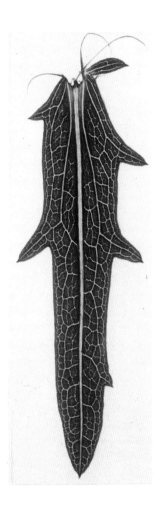

The Inspiration of Landscape

ARTISTS IN NATIONAL PARKS

BRIAN REDHEAD

PHAIDON · OXFORD

in association with
CONOCO

Acknowledgements

Phaidon Press and Conoco gratefully acknowledge the permission of the artists to reproduce their works in this book.

All the works reproduced in this book were submitted for the Artists in National Parks project in 1988.

Photographic credits:
Lake District (p. 11) John Cleare/Mountain Camera
Peak District (p. 29) John Cleare/Mountain Camera
Yorkshire Dales (p. 30) Charles Meecham, Countryside Commission
North York Moors (p. 38) John Cleare/Mountain Camera
Northumberland (p. 42) Eric Dale, Countryside Commission
Dartmoor (p. 55) John Cleare/Mountain Camera
Exmoor (p. 60) John Cleare/Mountain Camera
Snowdonia (p. 62) Derek G. Widdicombe, Country Wide Photographic Library
 (p. 72) John Cleare/Mountain Camera
Brecon Beacons (p. 81) John Cleare/Mountain Camera
Pembrokeshire Coast (p. 85) John Cleare/Mountain Camera

Phaidon Press Limited, Musterlin House,
Jordan Hill Road, Oxford OX2 8DP

First published 1989
© Phaidon Press Limited 1989
Text © Brian Redhead 1989

T04593

A CIP catalogue record for this book is available from the British Library

ISBN 0 7148 2597 2

Printed and bound in Great Britain by
Butler & Tanner Limited, Frome

Frontispiece. Garry Fabian Miller.
Detail of *From the Heart to the Head (No. 28).*
Cibachrome photograph, 33 × 33 cm
(13 × 13 in). Private collection

1. (*Title page*). Adrian Berg.
Detail of *Derwent Water, Bassenthwaite and Skiddaw from Cat Ghyll.*
Watercolour, 35.6 × 106.7 cm
(14 × 42 in). Private collection

Contents

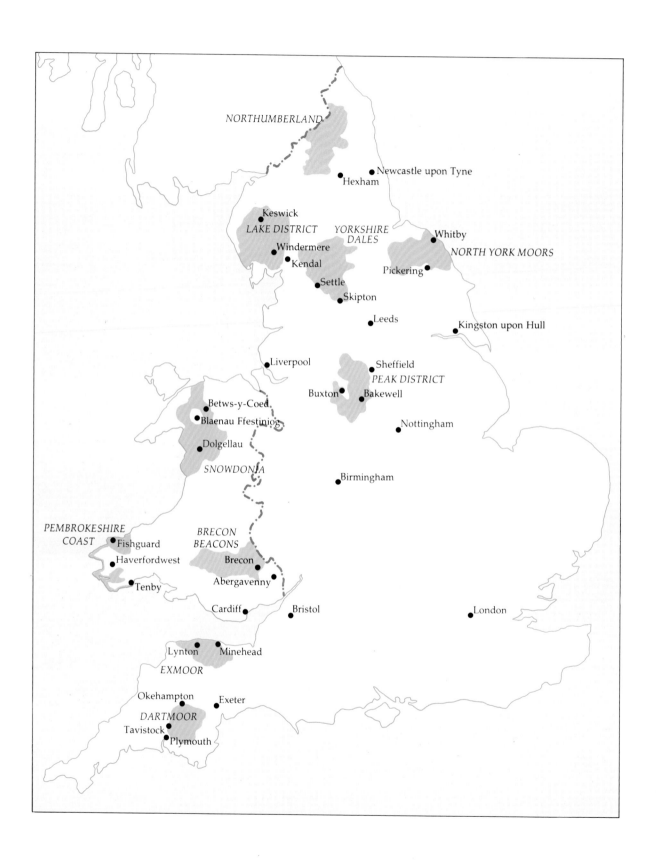

NORTHUMBERLAND

Newcastle upon Tyne
Hexham

Keswick
LAKE DISTRICT
YORKSHIRE
DALES
Whitby
NORTH YORK MOORS
Windermere
Kendal
Pickering
Settle
Skipton
Leeds
Kingston upon Hull

Liverpool
Sheffield
PEAK DISTRICT
Buxton Bakewell
Betws-y-Coed
Blaenau Ffestiniog
Nottingham
Dolgellau
SNOWDONIA
Birmingham

PEMBROKESHIRE
COAST
BRECON
BEACONS
Fishguard
Haverfordwest
Brecon
Tenby
Abergavenny
Cardiff Bristol
London

Lynton Minehead
EXMOOR

Okehampton Exeter
DARTMOOR
Tavistock
Plymouth

Introduction

The National Parks are the most beautiful parts of England and Wales. Every Park is different, but all ten of them should be seen not simply as scenery or as background but as wonders of creation – an experience not a setting.

The purpose of this book is both to capture and to share that experience. It is not a guide to the Parks, nor a description of them. It is not a political statement about the Parks, nor a prescription for them. Rather it is a revelation, an illuminating disclosure of what the Parks mean for us.

Eleven artists were commissioned to produce works for the Artists in National Parks project. Ten were ascribed a Park each, the eleventh was given a roving commission. Twenty more were invited and agreed to submit works for the subsequent exhibition.

That exhibition came as something of a surprise to those who had expected to see a set of pretty pictures, but it delighted those who wanted both to see an important collection of contemporary British art and to celebrate the National Parks.

Ted Hughes, the Poet Laureate, once said of the Peak Park: 'You do nothing casual here.' None of these works of art are casual encounters with the landscape, they are inspired by it. And this book is for those who feel the impact of that inspiration and know it to be true, but cannot always express it for themselves.

Map. The ten National Parks of England and Wales

The Lake District

Wordsworth had the first word, and wherever two or three people are gathered together discussing the National Parks, he is likely to be quoted. 'I do not know any tract of the country,' he said, 'in which, in so narrow a compass, may be found an equal variety in the influences of light and shadow upon the substance and beautiful features of the landscape.' And it was he who first proposed that the Lakes should become 'a sort of national property in which every man has a right and an interest who has an eye to perceive and a heart to enjoy.'

Wordsworth was not a visitor, he was a native. The Lake District was his home, the place where he had been born and brought up, the place where he returned to compose his life's work. For him, it has been said, 'the landscape was the message and he himself the landscape.'

He was as much the child of the Lakes as he was the child of his parents. In his great autobiographical poem, *The Prelude*, he describes how he felt at the age of eleven when his father died.

> 'Twas a day
> *Stormy, and rough, and wild, and on the grass*
> *I sate, half-shelter'd by a naked wall;*
> *Upon my right hand was a single sheep,*
> *A whistling hawthorn on my left, and there,*
> *With those companions at my side, I watch'd,*
> *Straining my eyes intensely, as the mist*
> *Gave intermitting prospect of the wood*
> *And plain beneath. Ere I to School return'd*
> *That dreary time, ere I had been ten days*
> *A dweller in my Father's House, he died.*
> *And afterwards, the wind and sleety rain*
> *And all the business of the elements,*
> *The single sheep, and the one blasted tree,*
> *And the black music of that old stone wall,*
> *The noise of wood and water, and the mist*

2. Julian Cooper.
Looking West, Scafell.
Oil on canvas, 177.8 × 203.2 cm
(70 × 80 in). Private collection

'Sellafield can be seen from the Scafells and other fell tops and serves as a reference in the painting to the fact that the growth of industry in other parts of the country, prompted the setting up of the National Parks.'

Which on the line of each of those two Roads
Advanced in such indisputable shapes,
All these were spectacles and sounds to which
I often would repair and thence would drink,
As at a fountain; and I do not doubt
That in this later time, when storm and rain
Beat on my roof at midnight, or by day
When I am in the woods, unknown to me
The workings of my spirit thence are brought.

For Wordsworth the Lakes were as much a wonder of creation as mankind itself. Then and now there are those who think he overdid it. Even his sister Dorothy sometimes thought he got carried away, and he confessed that this was true.

I too exclusively esteem'd that love
And sought that beauty, which, as Milton sings,
Hath terror in it . . .

But Dorothy too revelled in nature and her delicate observations, as recorded in her *Journal*, probably lured even more people to the Lakes than William's thunder. She enjoyed it; he sought to understand it, aware that the poet 'pleased within his own passions and volitions is delighted to contemplate similar volitions and passions as manifested in the goings-on of the Universe.' Then he added: 'And habitually impelled to create them where he does not find them.'

That habitual impulsion is what landscape inspires in the artist. The rest of us are content, as Dorothy Wordsworth was content, to walk, to look, to praise, and to remember. The artist wants to add to the creation.

Andy Goldsworthy (Pl 4), the artist commissioned to work in the Lakes, had never set eyes on the Lakes until he went to art college. He started working outside with the landscape directly in his first year at college and was drawn to the Lakes just seeing the snow on the mountains. He took to walking up the hills to that first snow.

For him the Lake District is not a tourist spot. If you go in a car as a tourist, he says, you will only see tourists. But if you get out and walk, especially in winter, you see the landscape.

For his project he chose to go in winter again. When he starts work he does not know what he is going to make or where he is going to work. Every day is a new discovery. He sets off and walks until he sees something he wants to work with, to understand.

3. Scafell Pike, Cumberland

4. (*Overleaf*). Andy Goldsworthy.
Calm
knowtweed stalks
stuck into muddy lake bottom
ends pushed into hollow stems to make a
screen
(Derwent water, Cumbria, 20th
February 1988). Photograph text,
43.2 × 20.3 cm (17 × 8 in).
Private collection

'The shapes I create are forms that I
have discovered in the material,
through understanding the material.

I take a lot of care in the making,
so I'm very demanding about what
the photograph should do. It should
be as clear and as straight as possible.
It is not taken from peculiar angles or
with strange lenses or filters. I use
standard equipment and that's a very
difficult thing to do in photography.'

He says that the way the light hits a material and affects a material is very important. He will often work something to a particular light, a quality of light. It is not only understanding the material, it is understanding the light.

In the work that he did in the winter, there was, he says, a beautiful thick grey light. He was really working with the sky. That to him, was like stepping out of a plane. That is the nearest he can get to describing walking into that still calm water.

The lake pieces were slightly unusual for him in that he had to wait for the weather. He would find a familiar spot and the necessary materials, and then wait for a calm morning sensing this to be a good setting. He spent a lot of nights looking out of the window, looking to see how calm the water was, and getting up very early and going down to the lake to find that stillness. And when he got down to the lake and found it absolutely still, the excitement of the stillness and the intensity of knowing that this moment might not last created an enormous tension. Having to work with the weather and the materials is not like working in a studio where you can switch the light on and off and where you are in control of the materials. It is a partnership. He was having to work to its tune and he liked that.

To make a work like this in the Lake District he has to understand the weather, the water's surface, the sky, the lake bottom — all these qualities — and put them together. When he achieves something like these works, in circumstances which border on the impossible, the sense of achievement, understanding and feeling for the place is incredible. You cannot get that feeling in any other way, he says. The places where he has worked are like homes that he might have lived in.

He built a wall on a piece of land that he owns in Scotland. Quite recently he went there and walked up to the mountain and looked down on the wall. There were plenty of other walls and there was his wall. He was delighted. Not because he thought 'E that's my wall' — not at all. It was a recognition that the land had been enriched by the touch of man over many years and his touch had extended that tradition. He believes that we are part of the landscape and should not see ourselves as separate.

The idea that we are separate is a very dangerous idea in ecological terms. As dangerous as the idea that we do not affect the land and that we are not a part of it. Because once you start thinking this you do not realize the implications of what you take and touch.

When Goldsworthy works with the land he is taking responsibility for what he touches and he is very careful about what he does.

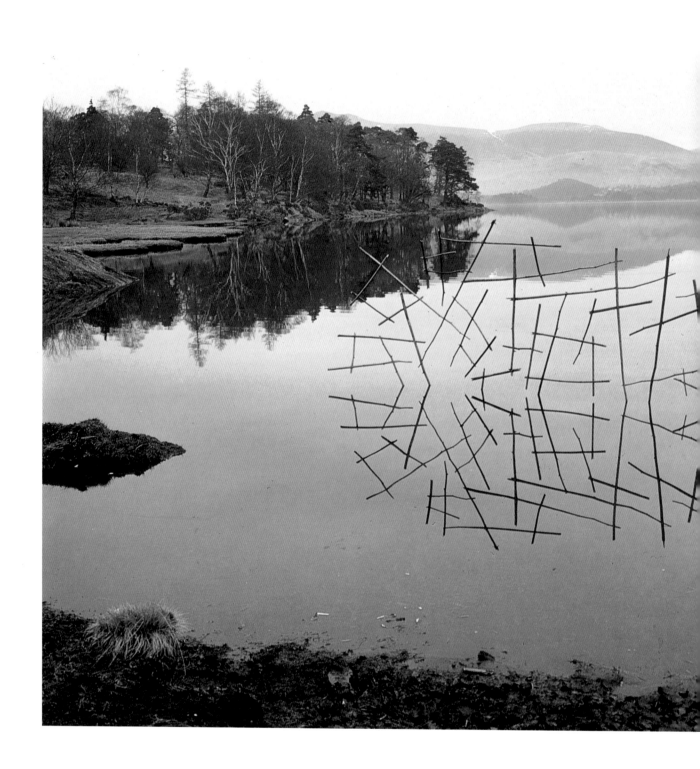

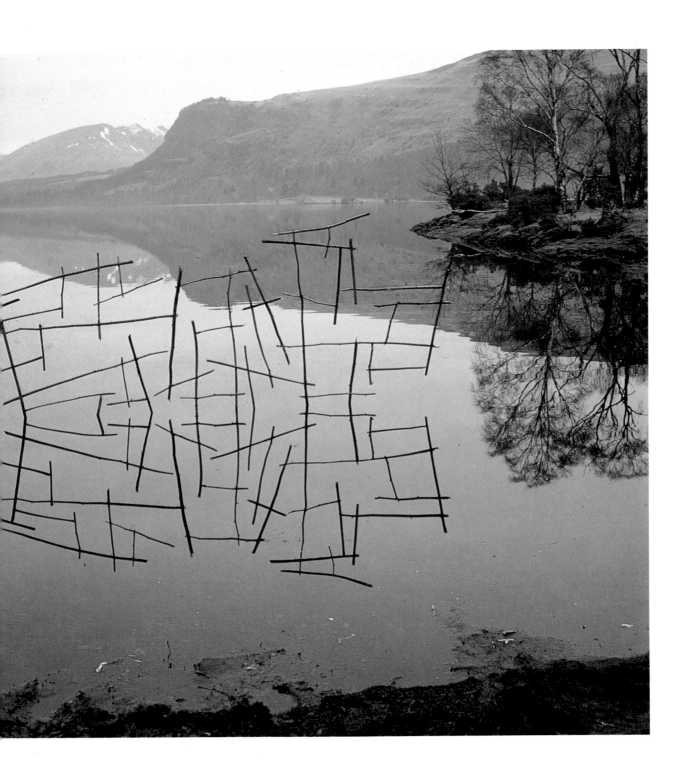

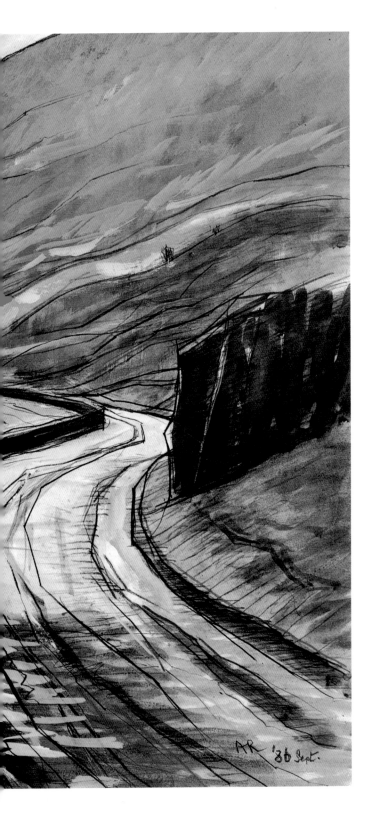

5. Anthony Rossiter.
Lake Buttermere.
Watercolour/crayon 83.8 × 104.1 cm
(33 × 41 in). Private collection

'The mist hung over Lake Buttermere
and the surrounding mountains like
parentheses in a stream of poetic
prose. As I painted I realized clearly
why Wordsworth had written "I
wandered lonely as a cloud"'.

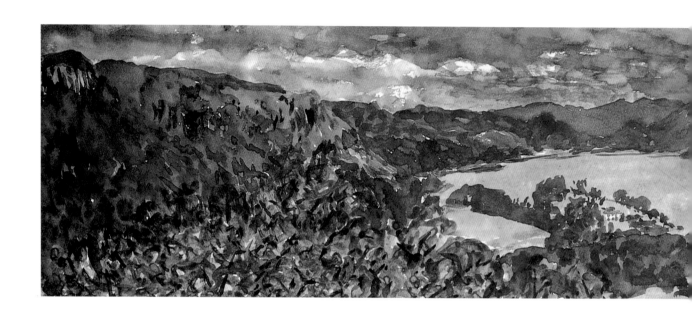

6. Adrian Berg.
Derwent Water.
Watercolour, 35.6 × 106.7 cm
(14 × 42 in). Private collection

'My subject is what man has made of
nature.'

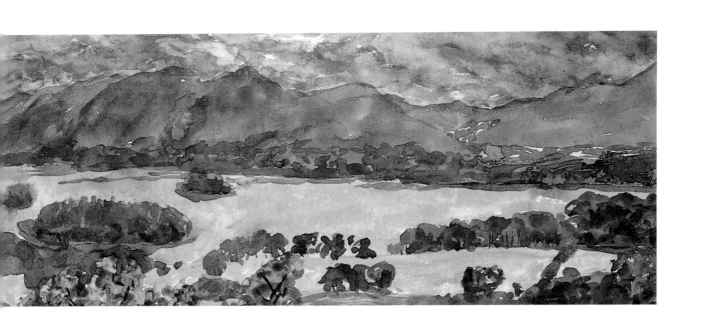

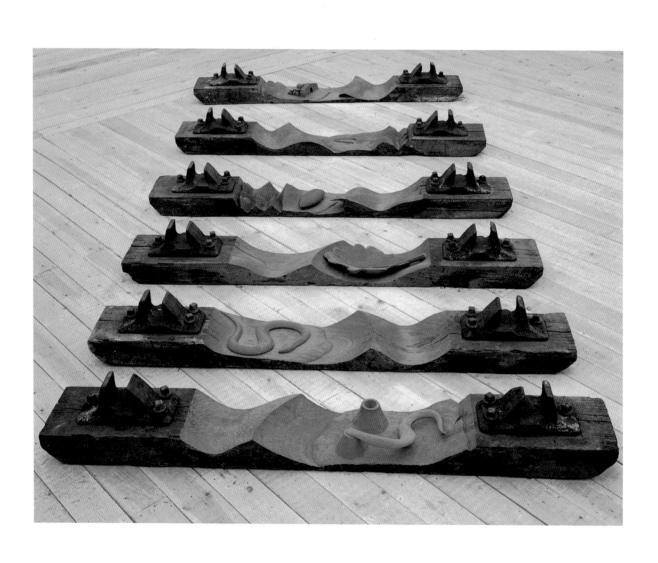

'I see myself,' he says, 'as a kind of object in the landscape, and an object that goes around affecting the landscape by touching. And when I put myself in there I treat myself as an object, as part of the sculpture. I felt I really got through in the lake pieces. I had touched it, and understood it.'

Julian Cooper believes that landscape can be used as a neutral receptacle upon which we project our inner feelings, or as a means of re-uniting us with the larger order of nature if we live an urban life.

He finds it difficult to follow the convention of leaving out of the picture the ever-present tourist, and to pretend that no one else is there. He thinks saturation point has been reached and wonders why the local tourist board continues to encourage greater numbers of visitors every year.

His painting is in the heart of the National Park but deliberately looks to its boundary and beyond. Looking west from Scafell you can see Sellafield, which presents, he says, a possible threat to life (Pl 2).

Keir Smith's works are based on the railway line that runs round the east side of the Park from Carnforth to Carlisle and which acts as an interval between the sea and the Lake District inland. 'I don't regard mankind as a parasite on the landscape,' he says. 'Sometimes mankind influences the landscape towards aesthetic values: sometimes he simply exploits. But there is a huge range in between and I find the subtleties of that interaction very exciting.'

He likes his work to point out that there is a multi-layered relationship in his response to the landscape. When he makes a work he is not simply attempting to find a picturesque view and then making something tangible that can be hung elsewhere. He is somehow trying to encompass the landscape in its diversity.

For him the Lake District is not just about the play of light on a mountain or on a stretch of water. It is to do with people having been there thousands of years ago, using the rock to make flint axes.

All the material he uses has a history. But he is also very conscious of what he calls instantaneous history – the foot print that can be washed away, the fragile leaf that can float away.

'The wave,' Smith says, 'is nature as a sculptor.' His little Sellafield carved into the railway sleeper is an acceptance of the modern world, but the fact that it has a wave next to it makes it a threatened, precarious image, no more permanent than a footstep.

Wordsworth would have agreed with that.

7. Keir Smith.
Iron Band that Binds Green Heart.
Six carved railway sleepers, each
30.5 × 213.4 × 12.7 cm
(12 × 84 × 5 in). Private collection

'There is something, some look in the proportions and in the resonances that the sleepers have, which has a response deep within my psyche. Every time I think I've finished a series, I say "right I'll never do one again". But ideas keep turning out.'

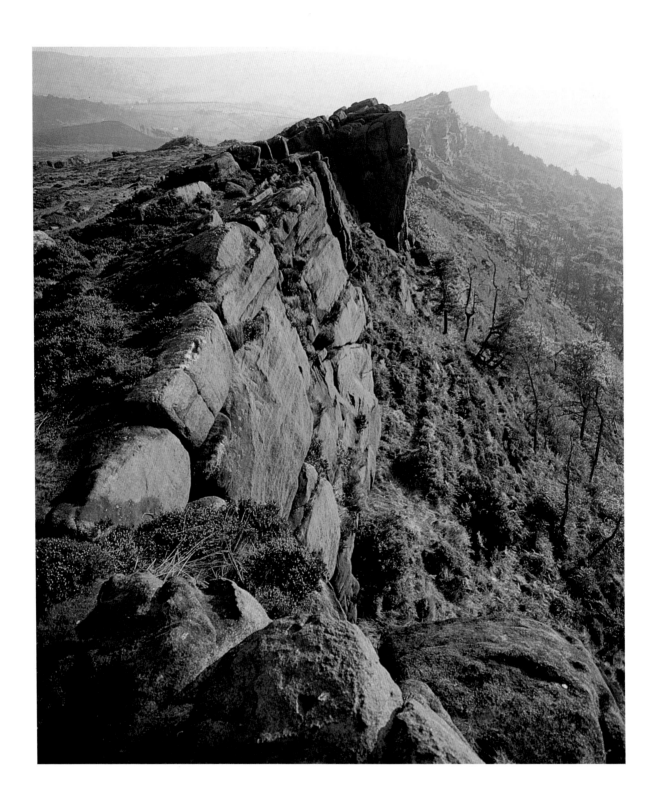

'It is a country beyond comparison uglier than any other I have seen in England, black, tedious, barren, and not mountainous enough to please one with its horrors,' said Thomas Gray in 1767 in a less than elegiac letter. But Gray was like that, timid and fastidious, he trembled before the wilder manifestations of nature.

And the Peak can be daunting.

The upper millstone heaven
Grinds the heather's face hard and small

wrote Ted Hughes, seeing the sky and the Pennines as a pair of millstones. A walk along the Pennine Way here is never a stroll and always an adventure.

The Peak may be handy for the huge populations of the industrial North, the back garden of Manchester and of Stockport, of Sheffield and of Derby, but it is both the wildest of open countryside and the most lived in. Give or take unwelcome quarrying, it is not cluttered – the barren hills stretch from horizon to horizon, but none the less this has been occupied territory for 10,000 years.

And the stories that linger would have Thomas Gray scurrying back to his tea and buns. My favourite is the story of John Turner, whose departure from this world is marked by an inscribed stone at Saltersford. On Christmas Eve, 1735, Turner, who ran a string of pack-horses between Chester and Derby, was returning to his home in Saltersford through a snowstorm. Anxious to be with his family in time for Christmas Day, he ignored the warnings and pressed on through the blizzard. When he failed to appear a search party was sent out. It found his horses safe, but Turner was frozen to death less than a mile from his home. In the snow beside him was the footprint of a woman. And no one has ever discovered who she was.

Winnats Pass, the most beautiful limestone gorge in the kingdom, was the scene in 1758 of a robbery and a murder. The

8. The Roaches, Staffordshire

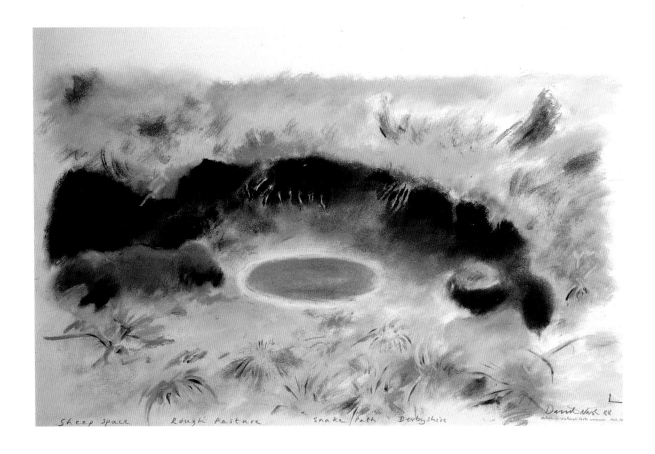

Sheep space Rough Pasture Snake Path Derbyshire David Nash 88

9. David Nash.
Sheepspace, Rough Pasture, Snake Path.
Oil on pastel, peat and sheep
droppings on paper, 83.8 × 124.5 cm
(33 × 49 in). Private collection

'The sculpture that I do is appropriate
to a particular place and it stays in that
place. It is made from and for that
place. The sheep spaces are like that.
They could be nowhere else – the
sheep have made something from
what is there.'

10. Eileen Lawrence.
Prayer Sticks nos. 58, 56 and 57.
Watercolour, each 243.8 × 15.2 cm
(96 × 6 in). Private collection

Totems of a bleak landscape at the
crossroads of Britain.

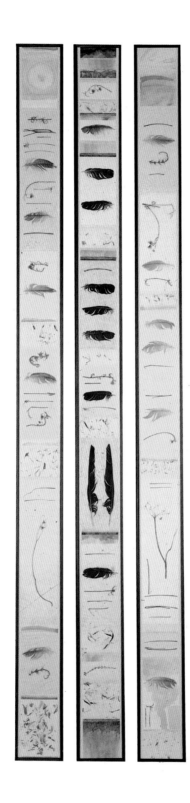

victims were a pair of runaway lovers. Their murderers were never caught, but many years later a lead miner on his deathbed confessed that he and four companions had committed the crime. All had died either in hideous ways by accident or suicide. This, said a contemporary report, was 'the most striking instance of Divine Judgement on record.'

In 1812 a highwayman called Anthony Lingard was hanged at the crossroads at Wardlow Mires in Derbyshire for the murder of a widow who kept the local toll-gate. His corpse was the last to swing from a gibbet in the country. It attracted such a crowd that the local lay-preacher had to leave the church at Tideswell for lack of a congregation and give his sermon at the gibbet instead.

The Peak is that kind of place. It is, in every sense of the word, dramatic. It is the scene of drama, the cause of drama, the essence of drama. It is impossible to set foot in it without being aware that others have set foot here before. Not that they have left their paraphernalia behind (they would not dare) but they have left their presence, as Yeats put it in his fine poem *Memory*,

> . . . *the mountain grass*
> *Cannot but keep the form*
> *Where the mountain hare has lain.*

Perhaps this idea was at the back of David Nash's mind as he approached his commission to work in the Peak (Pl 9).

He had been looking at different ways of communicating about the land, and one of his observations was the way that animals use it. Sheep need to find shelter from the wind and the rain so wherever they graze one can find such places, 'sheep spaces'. If you actually get in them yourself, he says, they are amazingly well protected.

Up on the moorlands he chose four areas where there would be these 'sheep spaces'. He walked, made sketches and notes, and then in his studio made up the drawings.

There were four drawings in each group — which make up an atmosphere. 'When you have the four', Nash says, 'you are not just looking at a picture, you are looking much more at an atmosphere of the landscape'. It was a way of investigating a place, going in fresh with a definite idea. The spaces held the idea together.

'The term "landscape" is like "portrait",' says Nash. 'It is an expression of a distancing: here I am and there it is. But what has been happening in the last twenty years or so is that artists have been getting right in there. Saying no, it is not out there. It is here.

We want to make our images with what is here – here. That is why it is called land art rather than landscape art, "scape" denoting the distancing.'

Since the advent of the car he says we have become more distanced from the landscape. In the United States for example, not many people actually walk from one part of the city to another. The towns are like space stations and the roads are the links. What is different in Europe is that the ground to the depth of an arm's length has been turned over so that if you look out from an aeroplane you can see how the land has been moved, and churned and turned over, for thousands of years. There is a collaboration going on between man and nature.

Nash says he is always hearing about the idea of getting back to nature – but, as he points out, the towns got bigger and bigger because people were escaping nature, from the hardships of living in the country. So it is not about going back. It is about getting yourself free enough to feel all the elements. To feel that what is outer is inner and what is inner is outer.

'If we were consciously aware of the harmony of the world,' he says, 'the human being would never have dragged up coal, oil and radiation, radioactive material which is what our environmental problems all stem from. They are asleep, those great powers, and we have pulled them up. If we had been conscious of what it is to be part of and live on this earth, we would never have brought this stuff up because we would have known what it would have done. Evolution seems to be a continual cliff hanger, going from crisis to crisis. We have to have the crisis. There must be continual threat.'

The Yorkshire Dales

When *The Economist* once suggested that Parliament should move out of London and settle in Yorkshire, a farmer from the Dales wrote to *The Yorkshire Post* and pointed out that there was no need. Parliament meets in Hubberholme every year, he said.

He was referring to an ancient custom. Every New Year's Eve in The George, the local inn at Hubberholme, the vicar and the churchwardens gather in one room, known as the House of Lords, and the village farmers in another room, the House of Commons.

The two sides then negotiate for the following year's tenancy of a field called Poor's Pasture. The rent is fixed and the money is given to the poor of the parish. And that is how it should be, wrote the farmer.

His stricture is almost a definition of the Dales. They are as they should be. Thomas Gray, as always, shuddered when he saw Gordale Scar. He stayed a full quarter of an hour, he said later, and thought his trouble richly paid because the impression would last for life.

Karl Weschke came to Gordale Scar by another's painting. When he was very young he saw James Ward's masterpiece *Gordale Scar* and was dismissive. Over the years, perhaps, as he says, because of an accelerated emotional acclimatization to the country he had chosen to live in, Ward's painting became for him an object of speculation and continual reassessment.

He came to admire it and began to wonder what the source landscape looked like and hoped that one day he might paint it himself. When, therefore, he was asked to paint any one landscape in the National Parks, his choice was effectively already made.

He travelled to Malham to see and paint the Gordale Scar (Pl 11). He found it as splendid as Ward's painting but his own experience of it was totally different. From many drawings at the site he then painted the picture in his studio.

Landscape, Weschke says, is time enduring. It is not unreasonable, he believes, to argue that with the passage of time the land has

11. Karl Weschke.
The Gordale Scar.
Oil on canvas, 172.7 × 218.4 cm
(68 × 86 in). Private collection

'A particular landscape or landscapes in general affect us so profoundly because they bring to mind the timelessness they hold.'

fashioned and shaped both the mind and body of our species. Over the centuries man has formed affinities with varying environments and climates, and during this process there has evolved in him an awe of landscape, for which he has developed visual similes of different types.

But he also argues that in some cases a reversal has taken place. Now it is almost as if we are stimulated into going to see a landscape because of its portrayal in a picture – just as he was.

He lives at Cape Cornwall and is made aware daily of how primordial the coastline is. Early man, climbing over the rocks and headlands, was very much at the mercy of his environment. And we still are. The heedless visitor or tourist of today is prey to the freak wave or the crumbling rock every bit as much as the ancient native was.

This is a very different picture from the gentle and inviting poster. Beauty, he argues, is very different from prettiness. Unlike prettiness, beauty does not implore or seduce. Beauty demands admiration and complete acceptance.

Garry Fabian Miller's knowledge of the Dales, before he began work on this commission, was largely confined to Wensleydale, and to the ruins of various abbeys. He was also very interested in Brig Flats, just outside Sedbergh, which is one of the earliest Quaker Meeting Houses in Britain.

For the commission he went to Swaledale because it is the most northerly of the Dales and one that he did not know at all. 'Once you are in it,' he says, 'you are surrounded by it' and the size and the intimacy appealed to him. He decided to make a work about a journey through the seasons, from the heart of the Dale to the point where the river comes out of the ground. So he began in high summer at Richmond Castle and went along the river below the Castle to Hag Wood. He spent two months there. Then he spent two months in the autumn fifteen miles upstream. Finally in January he went to the source of the river. He spent several days at a time studying a very small area of landscape observing very small changes in things, examining the plant species.

Then within these species he would look for plants which said something specific about the species in each location. What he tries to do, he says, is to use a method of making pictures which enables him to show, record and share as directly as possible the beauty contained within the plants and trees he works with.

Through a chain of accidents he hit upon the idea of taking the actual leaf of a plant or a tree, putting it into the head of a colour

12. Garry Fabian Miller.
Details of *From the Heart to the Head*.
80 Cibachrome photographs, each
33 × 33 cm (13 × 13 in). Private
collection

'When the sunlight penetrates a leaf it reveals its structure and so I looked for a way of making pictures about light shining through objects.'

photographic enlarger, and shining light from the enlarger through the leaf so that its image falls onto the photographic paper and records the object in all its detail (Pl 12).

He sees himself working in a tradition which is broadly religious. He quotes a study of medieval stained glass which says that the windows were mirrors of instruction, of nature, of morals, of history, and of truth. His images are very like the objects we see in stained glass.

13. Arant Haw, Howgill Fells, Yorkshire

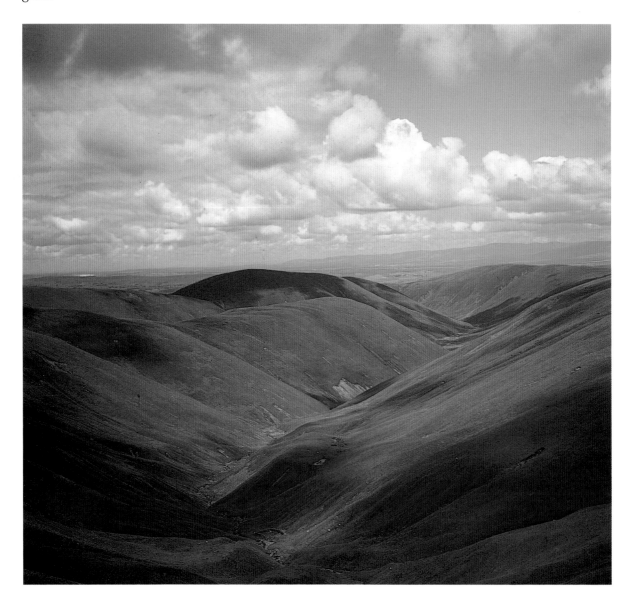

THE YORKSHIRE DALES 31

He is influenced by this sense of the power of light and all the symbolism behind it and the way it penetrates living objects to give them life. Also he sees them as icons, there to make people value and view with reverence the smallest things which make up the planet. He seeks to deduce eternity from a single leaf.

What inspires him in the landscape he says, is the way that the trees are plants which make up the fabric of the landscape, and live their lives in spite of all that is happening to them and around them. They seem to live with a kind of integrity and openness which gives him confidence. All these invisible acts going on within nature give him great hope.

For him the religious history of a landscape, too, is important. The ruins of monastic houses in the Dales say something about man's relationship to nature. They are grand buildings with a simple austerity rooted in the history of the Dales. And the Quaker meeting places are also the kind of spaces art galleries aspire to. Clearing away detail allows the concentration to focus.

Making his pieces he realized that many of the simplest plants in the landscape involve the 'cross' form, presenting themselves in a very open and vulnerable way. They are a world away from a Christ covered in gold on a crucifix, but the simpler, he says, is the one which has the greater truth.

People he believes are searching, journeying to find their place within the world and a balance within their lives. And it is something they intuitively seem to feel is contained in nature. The tremendous growth in the interest in the environment is surely an expression of belief, of the desire to belong. That for him is the inspiration of the landscape.

The North York Moors

'Mountains I have no love for; they are accidents of nature, masses thrown up in volcanic agony. But moors and fells are moulded by gentle forces, by rain, water and wind, and are human in their contours and proportions, inducing affection rather than awe.'

Thus wrote the writer Herbert Read, who was born in Ryedale, in a world both secluded and secure. The love of landscape, he said, must feed on intimacy as well as on magnitude.

Laurence Sterne, the one time vicar of Coxwold, the most southerly village in the National Park, was more maudlin. He is buried just opposite the home where he wrote his famous novel *Tristram Shandy*. At the other end of the village is Newburgh Priory, a twelfth-century Augustinian foundation, where Oliver Cromwell's body is said to be entombed. About a mile and a half away are the ruins of Byland Abbey, a Benedictine Monastery built by rebel monks from the abbey at Rievaulx. Sterne strolled there most evenings.

'To this place, after my coffee, unless prevented by inclement skys, I guide my daily steps. The pathway leads, by a gentle descent, thro' many beautiful and embowering thickets – which gradually prepare the mind for the deep impressions which this solemn place never fails to make on mine. – There I rest against a pillar till some affecting sentiment brings tears upon my cheek – sometimes I sit me down upon a stone, and pluck up the weeds that grow about it – then, perhaps, I lean over a neighbouring gate, and watch the gliding brook before me, and listen to its gentle murmurs: they are oftentimes in unison with my feelings. Here it is I catch those sombre tints of sentiment which I sometimes give to the world – to humanise and rob it of its spleen.'

Wordsworth would not have put it quite like that. He was married to a local girl, Mary Hutchinson, in North Yorkshire at

14. Richard Sorrell.
Rievaulx Abbey from Terrace.
Watercolour on paper, 73.7 × 55.9 cm (29 × 22 in). Private collection

Rievaulx, the most beautiful and the most natural of all English Abbeys. As Herbert Read said, 'its precise geometry seems, like some crystalline symbol of the natural beauty around it . . .'

15. (*Overleaf*). Len Tabner.
Staithes Harbour Mouth, Very Heavy Seas, Feb. 1988. Watercolour and pastel on paper, 104.1 × 155 cm (41 × 61 in). Private collection

'I never compose pictures. For instance with the breakwater I'm constantly finding new places to stand. Things change dramatically in just a few feet.'

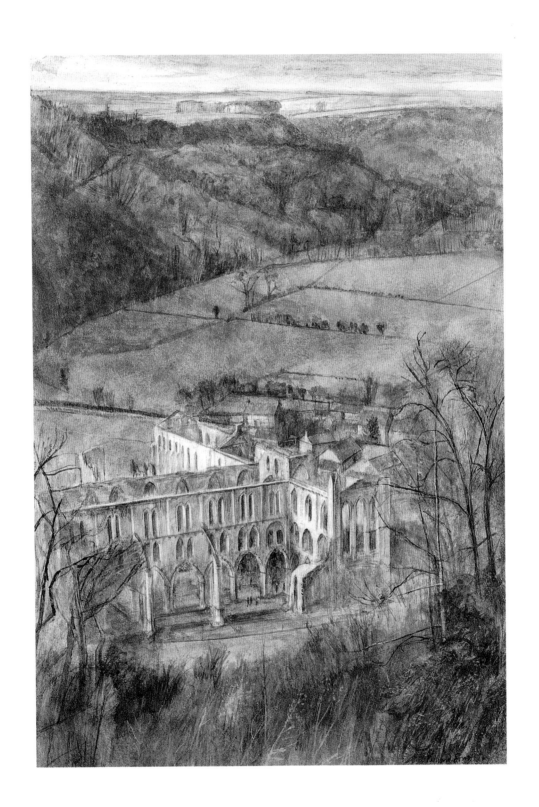

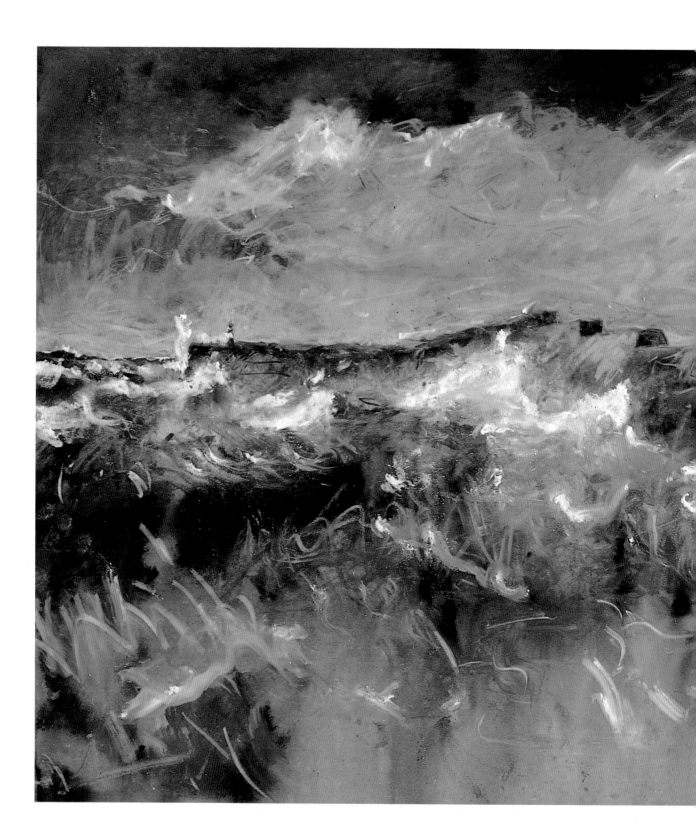

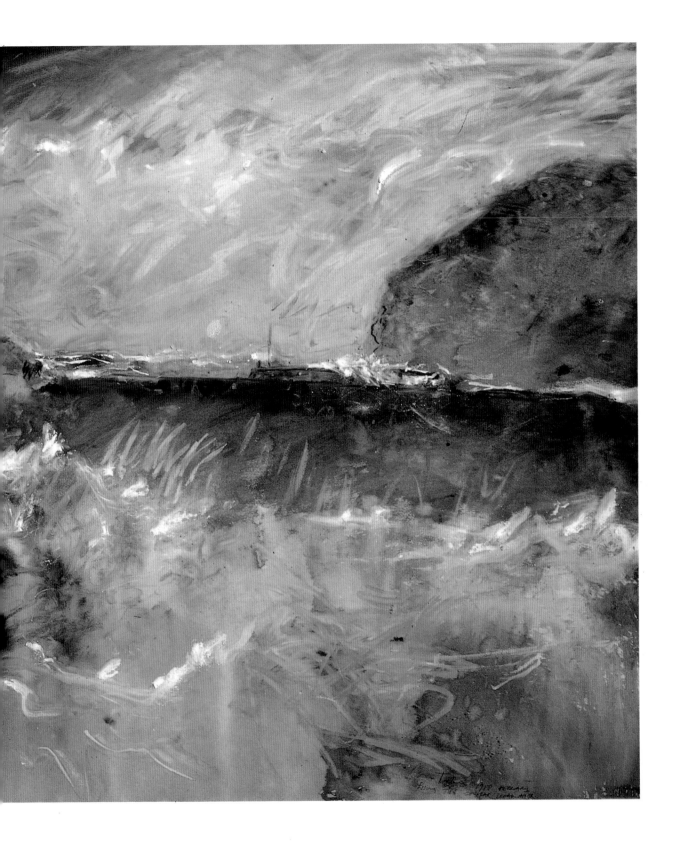

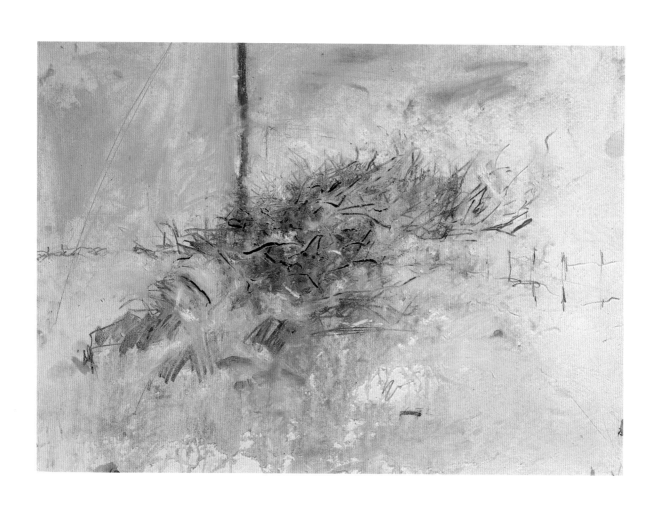

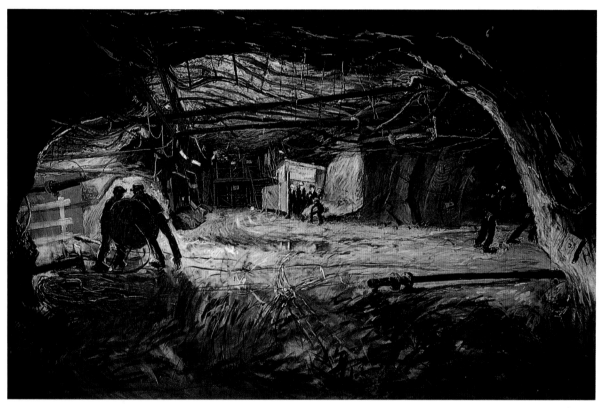

16. Len Tabner.
Hawthorn in Snow.
Watercolour and pastel on paper,
78.7 × 104.1 cm (31 × 41 in). Private
collection

'I have been working on this thorn
bush for over ten years, in all weathers
and lights.'

17. Len Tabner.
*Belt Interchange, Cleveland Potash Mine,
Boulby. Tommy Lister just approaching.*
Charcoal and pastel, 106.7 × 157.5 cm
(42 × 62 in). Private collection

'I have worked in the landscape 4,000
feet below, because I felt I needed to
know what was going on. It's part of
this landscape.'

Brompton. Fifty years later, and fifty years before the Wright Brothers, the squire of Brompton, Sir George Cayley, built an aeroplane. It was a glider and it flew fifty yards across Brompton Dale carrying the coachman. He immediately gave in his notice. 'I was hired to drive not to fly,' he said.

It is not recorded what happened to him next. Perhaps he went on the Lyke Wake Walk, a forty mile journey across the Moors which is said to be named in an ancient ballad after an imaginary flight by a man's soul over the moors. Lyke means corpse. Any one who completes the walk in twenty-four hours is eligible to join the Lyke Wake Club and to wear a 'coffin' badge.

Wordsworth was a prodigious walker and would have made short work of the Lyke Wake Walk or indeed of the coast to coast walk that runs from Robin Hood's Bay to St Bee's Head on the Cumbrian coast. There are those who draw a line along this route, between west and east, to mark where the Vikings halted. The place names give the game away, but as Wordsworth said: 'Another language speaks from coast to coast.'

It is the language of landscape.

18. Cleveland Way/Lyke Wake Walk, Yorkshire

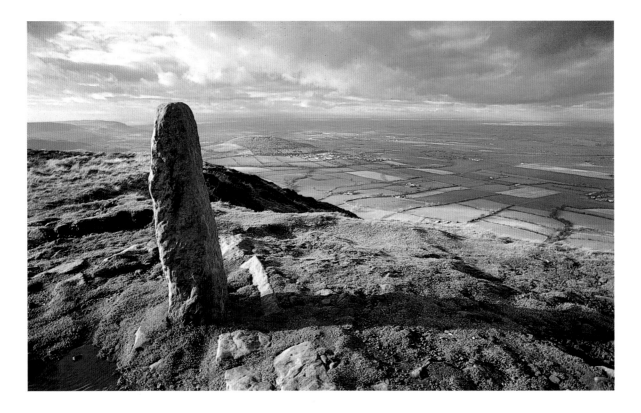

The North York Moors is more than moorland. It has deep dales and a spectacular coastline, and it is much lived in. The engineer, as well as the farmer, has made his mark upon it. And that pleases Len Tabner, the artist commissioned to work in the Park.

Len works here always. He lives in a cottage at Boulby near the top of the highest cliff on the east coast of England. He bought the cottage when he was a student for £400. He earned the money working on drilling rigs in his summer holidays.

Today he works close to the house. There is a thorn bush just down the road that he has been working on for more than ten years (Pl 16). He works on the landscape, he works on the sea, and he works on heavy industry.

He was brought up in an area of heavy industry, South Bank, Middlesbrough. He has always been interested in industry, especially in the processes, where men strive with the elements. These, he says, put them in common with the landscape. In a blast furnace, he says, men struggle with fire to extract iron from the earth.

Exposed to the full force of winds from the North Sea, Len's cottage is certainly no stranger to struggle with the elements. He came to live here because it was near the sea and also because it was part of a working environment, not somewhere cosy.

His father had a boat on the Tees, a traditional Yorkshire fishing coble. Len spent a lot of time as a boy at sea in his father's boat, in all sorts of weather. And that, he says, has had a tremendous effect on what he has done since.

Wordsworth would understand that. The most famous passage in *The Prelude* describes his feelings after rowing across the lake on a moonlit night.

> *There, in her mooring-place, I left my Bark,*
> *And through the meadow homeward went, with grave*
> *And serious thoughts; and after I had seen*
> *That spectacle, for many days, my brain*
> *Work'd with a dim and undertermin'd sense*
> *Of unknown modes of being; in my thoughts*
> *There was a darkness, call it solitude,*
> *Or bland desertion, no familiar shapes*
> *Of hourly objects, images of trees,*
> *Of sea or sky, no colours of greenfields;*
> *But huge and mighty Forms that do not live*
> *Like living men mov'd slowly through the mind*
> *By day and were the trouble of my dreams.*

When Len Tabner first came to his cottage to work he wanted to get back to basics. For the first seven or eight years he worked only in monochrome, with pencil or charcoal, making studies of the landscape and exploring the feeling of being present in space.

Weather is very important in what he does. The feeling of the weather and the air and the light are critical to his work. And he now works wholly out of doors.

That is how it needs to be, he says. It is the feeling of being in the landscape. And it is an activity in the landscape, like building a drystone wall.

He paints to explore the landscape. He does not go out with the idea of making pictures; he goes out in the hope of discovering something. And it is the light which lures him out.

'There are times,' Tabner says, 'when a very familiar place takes on a magical quality because of the light, the wind, and the air.' He finds it very often towards dusk: he is often still painting when he can scarcely see what he is doing and yet he can see the landscape in a new light.

All his works are completed outside because he feels the need to have things happening in front of him as he paints. He has been working on that thorn bush for all these years in all weathers and lights. And because he is interested in the power of the sea, he tends not to draw the sea when it is calm and placid.

He likes to paint when something powerful is going on and he likes to be outside in it. He can be in a landscape for days and nothing will happen; then suddenly it is all go.

Snow is something that excites him: suddenly everything is turned inside out. The land is white. The sky is darker. Everything is cleansed. And the air is filled with particles of snow. Everything has changed; but it is also very temporary.

He is particularly interested in what he calls the fullness of the air – when the air is full of water, especially from the sea. So that the sky above the sea is water and the sea and the sky seem to be one.

Shortly after he moved to Boulby a potash mine was sunk a few hundred yards from his home. It is an intrusion on the landscape: the mine buildings might have been more successful if they had been designed by engineers rather than by planners.

But even if he finds the buildings unpleasant, he is fascinated by the activity of mining underground. 4,000 feet beneath his studio there are people at work. That too, he says, is part of the landscape and of man's struggle with nature. He has made over 500 paintings inside the potash mine (Pl 17).

There is a slate tip near his home and he feels strongly about that too. It is one of only about three remaining from the days of the iron stone mining. The others have been flattened, or 'landscaped' as they put it. But he thinks that landscaped is a very arrogant term. The want to destroy this beautiful tip, he says, because it reminds them of the past. But it is a beautiful thing in the landscape and it is a monument to the activity which made the area what it is. 'No one,' Tabner argues, 'would think of flattening Silbury Hill.'

He even has an affection for concrete pill boxes left over from the Second World War, and for listening boxes left over from the First World War. He thinks there is a danger that we can become too tidy. The landscape is not simply an inspiration towards neatness and order. There is still a place for the casual monument and above all for the wildness and the wet.

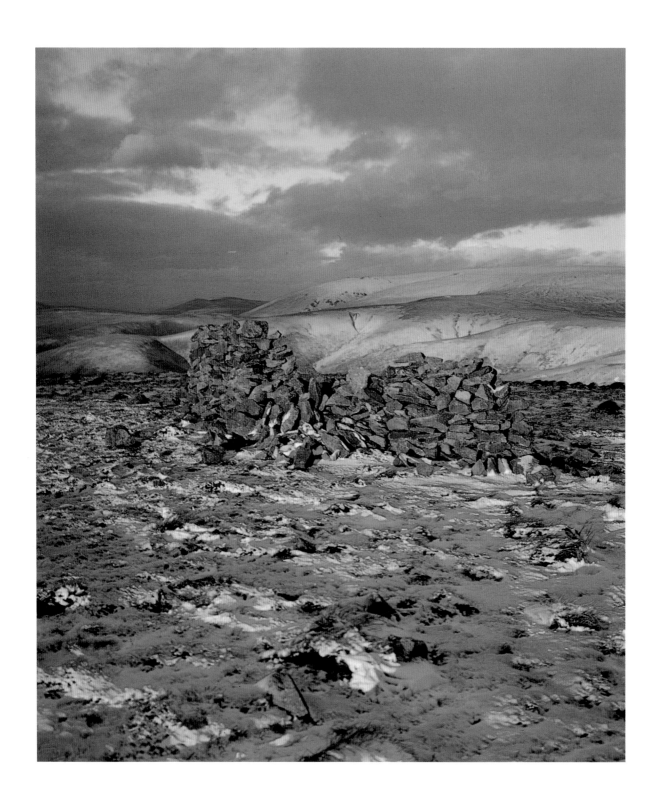

'What made me choose Northumberland of the ten National Parks was my sight of it in other summers', says Peter Greenham. 'The clouds seemed to be as solid and sharp as the trees, and the trees as exalted and forbidding as the sky.'

G. M. Trevelyan, the historian, whose family occupied Wallington Hall, the finest house in the Wansbeck Valley, was of the same opinion. 'The clouds in Northumberland,' he once wrote, 'are like an army waiting on the horizon.'

'Northumberland is a dark country, except in winter, when the sun shines through the bare trees. It is one of the few places in England where one no longer seems to be trapped in a small island.'

He was right. Northumberland is like a kingdom in itself, with its own geography, its own history, and its own freedom. The Romans drew the line at it, putting a wall between their conquests and everything to the north. But between that wall and the River Tweed a whole civilisation flourished.

Northumberland is the least populated and the least visited of the ten National Parks, and most of the locals prefer to keep it that way. It has the lowest density of population in England and Wales. When Paulinus baptized 3,000 Northumbrians on one day in AD 627, that must have been the whole population.

The Northumberland National Park is a landscape of wide open spaces, where access is unrivalled and solitude easily found. Seventy per cent of it is open moorland. And yet it also contains the finest Roman monument in the land, the largest military training area in the north of England, and the biggest man-made lake and man-made forest in Europe.

That is its majesty. It is rich in history and yet it feels as if its geography has not been tampered with. Every inch of it has a story to tell, stories of Roman occupation, of Christian conversion, of border conflict. And every inch of it has been exploited, directly or indirectly.

19. Cheviot Hills, Northumberland

20. Peter Greenham.
View from the Road between Cambo and Hexham.
Oil on canvas, 66 × 86.4 cm
(26 × 34 in). Private collection

A place where you could fancy a Roman Soldier might still say 'Good Evening'.

21. Peter Greenham.
The Cheviots.
Oil on panel, 35.6 × 50.8 cm
(14 × 20 in). Private collection

There are two great poems recording
the battle between the Douglases and
the Percys for the hunting rights over
the Cheviot: a Scottish ballad called
The Battle of Otterbourne, and the
English *Ballad of Chevy Chase.*

But it does not feel like that. It feels as it must always have felt with the clouds on the horizon and the wide sky. It is too large a landscape to be diminished by the activities upon it. Equally, those who have acted out their lives here have an heroic dimension. The great Christians, Paulinus, Aidan, Cuthbert, Bede. The great warriors, like James, Earl of Douglas and Harry Hotspur. There have been villainies too and acts of despair. But it is as if everyone counted, and the landscape counted most of all.

It is the continuing inspiration of everything that has gone on here. A landscape that cannot be ignored, amended or deceived.

If Hadrian were to return, or Harry Hotspur or Charles Trevelyan, they would not feel out of place. Northumberland is one of the few places in the world where what went before seems like part of your own life and not something distant, remote or bewildering. The space makes time relative. It is not a question of the old and the new, but of episodes of the same. It would come as no surprise on Whin Sill if a Roman soldier were to say, 'good evening'. He always did.

This continuity is the character of the place, the confirmation that people have gone about their business here over the centuries under the same forbidding sky.

Peter Greenham made his sketches on the spot, sometimes sheltering in a lay-by on the Cambo – Hexham road, seeking to capture those solid clouds, and trying to remember who won the Battle of Otterburn (Pls 20 & 21).

Not Harry Hotspur. The battle took place at night in 1388 and Hotspur's men were tired after a forced march. The Scots force was led by James, the Earl of Douglas, who, the ballad says, had a premonition that he would win.

> *But I hae dreamed a dreary dream*
> *Beyond the Isle of Skye,*
> *I saw a dead man win a fight,*
> *And I think that man was I.*

It was. Douglas died in victory. Harry Hotspur was captured and ransomed, and he got his own back fourteen years later at the Battle of Humbleton Hill.

Not every tale told in and about Northumberland is true. There is a lonely lake near Housesteads called Broomlee Lough, where Roman soldiers probably swam. King Arthur is supposed to have thrown his sword Excalibur into the lake as he lay dying. Wiseacres

reject that story but they still say that a box of treasure lies at the bottom of the lake, and when the wind agitates the surface, the patch of water above the box remains calm and unruffled.

When he toured the whole island of Great Britain, Daniel Defoe wrote:

'I must not quit Northumberland without taking notice, that the natives of this country, of the ancient original race of families, are distinguished by a shibboleth upon their tongues, namely a difficulty in pronouncing the letter r, which they cannot deliver from their tongues without a hollow jarring in the throat, by which they are plainly known, as a foreigner is, in pronouncing the th; This they call the Northumbrian r, and the natives value themselves upon that imperfection, because, forsooth, it shows the antiquity of their blood.'

Michael Redgrave spent a summer in Northumberland practising that *r*. When he played Harry Hotspur at Stratford with it, scarcely anyone in the south understood him. A kingdom for a hoarse, as some wit said.

But Redgrave had fallen under the spell of Northumberland in the company of Jack Armstrong, piper to the Duke of Northumberland. Armstrong took him to a barn dance at Wooler. Burl Ives, the American folk singer went too. The local people made them welcome but they were not fussed over.

When the dance was over, they stood outside looking at the night sky, and Redgrave recited that great speech of Hotspur's beginning:

> *My liege, I did deny no prisoners,*
> *But I remember when the fight was done,*
> *When I was dry with rage and extreme toil,*
> *Breathless and faint, leaning upon my sword,*
> *Came there a certain lord, neat, trimly dress'd,*
> *Fresh as a bridegroom . . .*

And, as Jack Armstrong told the story, it could not have seemed more in place. That is the inspiration of Northumberland.

Dartmoor

'If we could make contours in hearts as we do in maps, to see their loves, we should learn what strange unexpected regions attain the deepest depth. Often we might discover that a place rather than a person holds the secret. It was so with my father. The wild country of Dartmoor, where he walked as a small boy, was to him a dark and refreshing well, from which the water of his life was drawn.'

Freya Stark, the traveller, wrote that forty years ago and no one has put it better. Dartmoor is a dark and refreshing well for those who walk it. A day trip in a car and a cream tea is no substitute.

Dartmoor is not one moor, but three. The North Moor and the South Moor are predominantly peat-covered plateaux though the North Moor rises at one point to over 2,000 feet, and High Willhays is the highest point in England south of the Peak District. The East Moor is more jagged, broken by the outcrops of tors and the incisions of cleaves.

Dartmoor is damp. The average rainfall is sixty inches a year and in the west a hundred inches. Snow is common in winter and farms are frequently cut off. And yet in summer it can be so warm that walkers complain of heat exhaustion.

Dartmoor is the only National Park where the area of broad-leaved woodland exceeds that of coniferous plantation and forty per cent of the park is common land. Hence all the walking.

Richard Long, who was commissioned to work in Dartmoor, walked in Dartmoor. His piece, *A Dartmoor Walk, Eight Days, England 1987* stopped the first visitors to the Artists in the National Parks exhibition in their tracks (Pl 22). For his picture simply traced (and re-traced) his tracks across the Moor, and then spelled out in capital letters a proclamation of his triumphal route, beginning: 'DEEP BREATHING TO GRIMSPOUND TO BENNETT'S CROSS TO MIDGES TO A NEW BORN CALF TO GREAT KNEESET TO A LARK ON A BOULDER TO COTTON GRASS TO THINKING TO A FOX SMELL ...'

22. Richard Long.
A Dartmoor Walk.
Pencil and lettering on paper,
160 × 106.7 cm (63 × 42 in). Private collection

'*A Dartmoor Walk* was made in seven days in the summer of 1987, camping along the way. It was about the experience of being alone in a place of nature, the topography, the weather, the naming of places, real time, autobiography, imagination. Each new walk carries with it memories of all the others. For me Dartmoor is a place of regeneration, knowledge, history and continuity.'

DEEP BREATHING TO GRIMSPOUND TO BENNETT'S CROSS TO MIDGES TO A NEW-BORN CALF
TO GREAT KNEESET TO A LARK ON A BOULDER TO COTTON GRASS TO THINKING TO A FOX SMELL
TO GREAT LINKS TOR TO RIVER FROTH TO DOZING TO SWEATING TO YES TOR
TO A STONE CIRCLE TO SHELLEY POOL TO WINDLESS DAWN TO ENERGY TO BLUE FLOWERS
TO A BUZZARD TO HANGINGSTONE HILL TO SOUTH TAVY HEAD TO WEST DART HEAD
TO BEARDOWN MAN TO MUSHROOMS TO CUCKOO TO A STONE ROW TO CUCKOO ROCK
TO A WHITE BONE TO GREAT GNATS' HEAD TO ERME HEAD TO A MOUND TO DRYING SOCKS
TO YEALM HEAD TO DEW-SOAKED TO A CLAPPER BRIDGE TO FLIES TO BARROWS
TO A DEAD SHEEP TO THE WHOOSH OF A PEREGRINE TO SITTING TO TINNER'S STONES TO A RAINSTORM
TO A HERON TO SCATTERED BONES TO MOONLIGHT TO DRYING THE TENT TO TAW HEAD
TO EAST DART HEAD TO TEIGN HEAD TO A CLOUD BURST TO THUNDER TO LONG STONE
TO PONIES DRINKING TO HAILSTONES TO LIGHTNING TO GOOD MEMORIES TO A ROTTING SHEEP
TO VIOLET FLOWERS TO AN OAK TREE TO AVON HEAD TO A SMALL STONE TO MISSISSIPPI RIVER BLUES
TO ROLLING THUNDER TO A FLY IN THE EYE TO NAKER'S HILL IN A SQUALL TO PLYM HEAD
TO SHEEP'S TOR TO BLUEBELLS TO BELLOWING CATTLE TO WHITE BLOSSOM TO A FARMYARD
TO A BROWN BULL TO DARTMEET TO COFFIN STONE TO CAWING TO HAMELDOWN CAIRN
TO A STRAND OF WOOL TO THE SMELL OF NEW BRACKEN TO MOTIONLESS TO PINE NEEDLES
TO STEPPING STONES TO HUCCABY RING TO LAUGHTER TOR TO GOOD FEELINGS

A DARTMOOR WALK

EIGHT DAYS
ENGLAND 1987

23. Brendan Neiland.
*Dartmoor Skyscape across Gidleigh
Common, 1988.*
Oil on canvas, 129.5 × 182.9 cm
(51 × 72 in). Dartmoor National Park

'All artists are vying with one another
for the onlooker's attention. We want
to keep them looking at our image,
and stop them moving onto the next.'

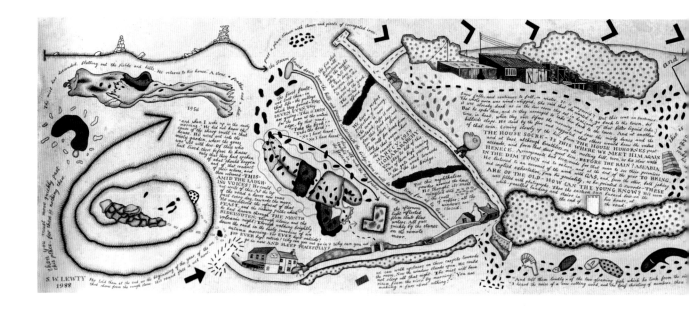

24. Simon Lewty.
Dartmoor, 'Known and Unknown'.
Pencil, pen, ink and watercolour on
paper, 58.4 × 213.4 cm (23 × 84 in).
Private collection

'A map of an inner landscape
containing fragments of the first visit
I made to Dartmoor as a child on
holiday with my parents as well as
elements of what I am now.'

that room at the top of the stairs.

to happen now, after this?

by this time the light had lift the sky.

there is a path which will lead us there.

is this then the way?

where must we go?

and what are we to do?

although it is late in the afternoon.

what will they do? what is

is found

is this then will follow it:

I do not know if there is anyone who would know. I do not know.

they will not return for many years

and came to an end of the road to know.

they no longer showed what he had said, they no longer did, or remembered what he had said. And who are you to say this? This morning sun flashed from the shining metal edge, but nearby, in the rough garden, two holes below the earth still remain; the EARLIER NOTICES OF THE GUIDE. Please may we come in again? That path leads only to where the rusting metal objects were collected from the bushes into which they had been thrown.

illimitable - there is a joyous load? Then's brief hold! At the black centre LUMUS. Stand but not trivial! veined in the way a stone is veined, washed by the sea. They will soon approach. Now you will eat the fruit!

They lift, to come to the CARELESS FIRE-HEAT in the bright cold morning, or in the evening damp! As for the fourth, the unvisited fourth, he sat sadly where one, earlier, had moved, only moved, to the side, to a chair, upholstered in stiff sexine, and had left. We broke in: "Would you like a - to name, now - THE RIGHT DAMP! It is on the shelves in the upper warehouse, in the attics DONDELY. His purpose - 6 GRAZE - his purpose - MERIOCK. Now in the morning I will have to work for miles down the lanes which link the farms at the edge of the moor. They did not see, or hear the one who came to the yard, and opened the gate, and went into the barn. They did not recognise the one who walked up the lane. Would say have spoken? You have been walking since early this morning, and it is now the middle of the day.

Now they have been in all these places. Same cooked and, as though they were still the same in force, all their were unchanged. He knew him first, but not by name, in the heat of the crowding and repetitious hill, and later, in their large place, and he grew accustomed to what had happened or ragain to remind of their parent before his pale eyes to seem like one coming locked up again, is seeing of his approach to moor.

Some visitors found Simon Lewty's map *Dartmoor 'Known and Unknown' 1988* (Pl 24) even more puzzling, not because it said too little but because it said too much. But Lewty believes that everything in our lives is linked and that nothing is wasted. We can recycle the past into the present.

His map is an inner landscape. He had not been to Dartmoor since he was a child and he did not re-visit it. He used his childhood memories, and his map is not simply what he saw then, but what he thought then. There are even passages from dreams.

'A map of inner landscape,' he says, 'is an important step towards understanding and self-knowledge.'

Heaven knows what Herrick would have made of Long or Lewty. When the poet was appointed to the parish of Dean Prior in 1629 he complained that the local people were 'currish', that is rude and churlish, and he protested that:

More discontents I never had
Since I was born, than here:
Where I have been, and still am sad
In this dull Devonshire.

He wrote over 1,000 poems at Dean Prior, the bulk of which are aptly described in his own lines:

I sing of brooks, of blossoms, birds, and bowers,
Of April, May, of June, and July flowers:
I sing of maypoles, hook-carts, wassails, wakes,
Of bridegrooms, brides, and of their bridal cakes.

And he managed a few kind words about his living:

Lord. Though hast given me a cell
Wherein to dwell;
A little house, whose humble roof
is weather-proof;
Under the spars of which I lie
Both soft and dry.

Herrick is said to have hankered for the literary life of London, though he returned to Devon to die, but he would appear to have preferred the picturesque part of country life and not the wilder times. He was not given to long walks across the Moor.

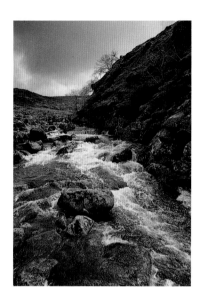

25. Tavy Cleave, Devon

Brendan Neiland, one of the invited artists who chose to work in Dartmoor, stayed on the Moor and paid for the hotel for himself and his family not with a poem but with a painting. Every day they went on walks.

One of the most stunning, he says, was the Abbots Way which crosses the Moor from Buckfast to Tavistock. Brendan liked it because it links up the great abbeys. He was brought up a Catholic and he felt a strong religious sense in the landscape. The ancient stones and burial grounds too contain for him a great strength, albeit of a pagan religion.

'At the best,' Neiland exclaims, 'Dartmoor has some strong feelings, some power even, over you.' It is a spiritual feeling, the undoubted presence of previous generations. It is a dark forbidding landscape, and he cannot help feeling that previous people had a terribly hard life. He wanted to convey this in his painting, not bleakness but toughness, the feeling of isolation, the feeling of cold (Pl 23).

He chose to paint an area around Gidleigh, but it is representational, he says, of a lot of the landscape of Dartmoor that he saw. He believes that when you are painting in the landscape you have to be true to nature. He wanted to portray the vastness of the sky by the distance of the sky, and the magnetism of the rock outcrops by silhouette. This painting, he says, is distant and silhouetted to give it a sense of the remote.

He does not use a paint brush, instead he sprays on acrylic paint. It would therefore have been impossible for him to work on the spot out on the windswept moor. Instead he took photographs and then spent five weeks in his studio in London creating the painting.

The spray is built in layers, rather like a glaze. Several thousand colours are involved in the painting and it evolves very gradually. He does a whole set of drawings, cuts them out, and uses them as the bases through which to spray. The colour mixture gives a brilliance and a resonance. The subtlety arises from the colour mixing.

His Dartmoor painting, he says, has a very strong structure. That is the excitement of doing it, it is not just painting, it is structure and emotion.

This painting has given him a new love in life – Dartmoor.

Exmoor

When Wordsworth went to live in the West Country in 1797, he was not made welcome. He had been to France and the Somerset people thought he was a French spy. 'You cannot conceive,' wrote Coleridge, 'the tumult, calumnies and apparatus of threatened persecutions which this event has occasioned around about us.'

The suspicions of a housemaid called Mogg were transmitted to the Home Secretary by a Doctor Lysons.

'I am informed,' the doctor wrote, 'that the Master of the house has no wife with him, but only a woman who passes for his Sister. The man has Camp Stools which he and his visitors take with them when they go about the country upon their nocturnal or diurnal excusions and have also a Portfolio in which they enter their observations which they have been heard to say were almost finished.'

Among other suspicious circumstances about the Wordsworths was their habit of 'washing and mending their clothes all Sunday,' and their being 'frequently out upon the heights most part of the the Night.'

The Home Office sent a detective who lay behind the sand-dunes on the shore listening to Coleridge and Wordsworth in conversation. The snooper was much agitated when he heard them talking about the philosopher Spinoza, whom Coleridge insisted on pronouncing 'Spy Nozy'.

But they were not plotting; Wordsworth was seeking to explain to Coleridge his inspired love of the landscape, and Coleridge had a great hunger and thirst in his soul.

'Frequently,' he wrote in a letter to a friend, 'all things appear little, all the knowledge that can be acquired child's play; the universe itself! What but an immense heap of little things? ... My mind feels as if it ached to behold and know something great, something one and indivisible. And it is only in the faith of that, that rocks or

26. James Faure Walker.
Exmoor, December.
Oil on canvas, 243.8 × 304.8 cm
(96 × 120 in). Private collection

'Working on Exmoor, I became fascinated by space. What is landscape space, is it two inches or ten miles? Is it the leaf before your face or the hilltop in the distance? The surface is constantly changing, flying before you, and vanishing like a river into the ground.'

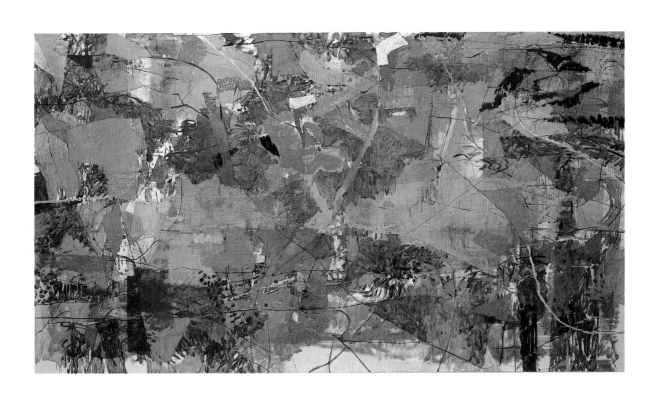

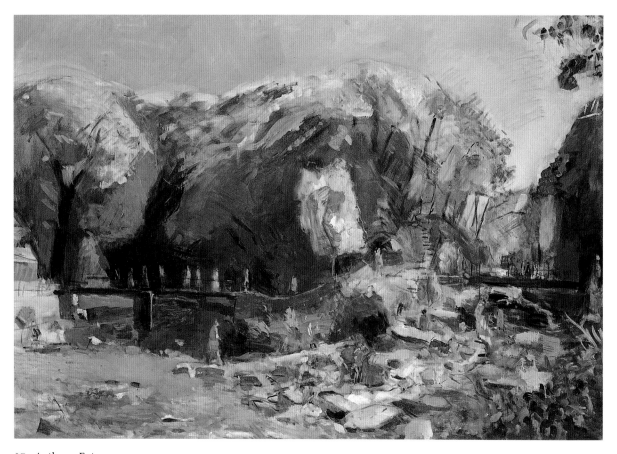

27. Anthony Eyton.
Watersmeet.
Oil on canvas, 144.8 × 251.7 cm
(57 × 77 in). Private collection

'I suppose you could say these
paintings are a "fête champetre" for
the common man.'

28. Anthony Eyton.
Wooded Stream.
Watercolour, 106.7 × 78.7 cm
(42 × 31 in). Private collection

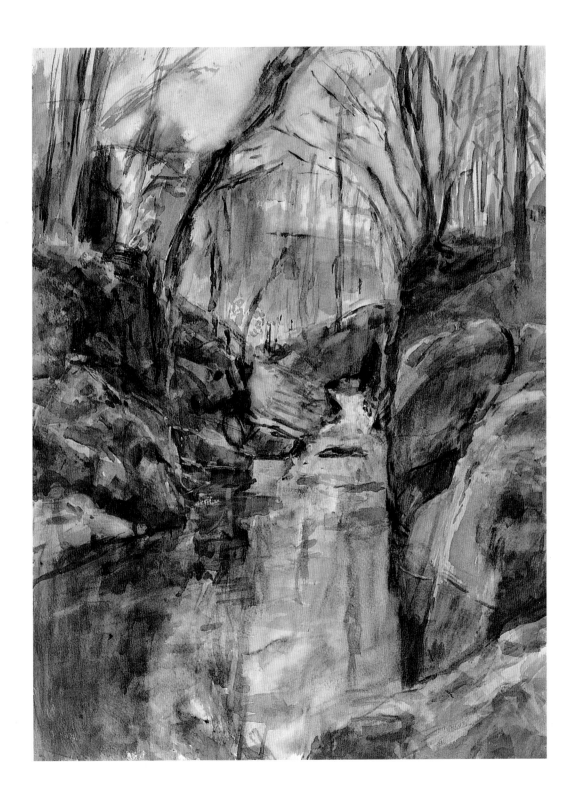

waterfalls, mountains or caverns, give me the sense of sublimity or majesty. But in this faith all things counterfeit infinity.'

And then he broke into verse.

Struck with the deepest calm of joy, I stand
Silent, with swimming sense; and gazing round
On the wide Landscape, gaze till all doth seem
Less gross than bodily, a living Thing
Which acts upon the mind and with such Hues
As cloath th'Almightly Spirit when he makes
Spirits perceive his presence . . .

This, says Wordsworth's biographer Mary Moorman, is very much akin to the visionary experiences that Wordsworth had had in boyhood and was still enjoying, though Coleridge characteristically gives it a theological turn.

Coleridge and the Wordsworths went on expeditions that autumn to Lynton by way of Porlock and the coastal path. It was in a farm house between Porlock and Lynton, a quarter of a mile from Culborne Church, that Coleridge, after taking a couple of grains of opium, dreamed the dream that was the vision that became *Kubla Khan*. A week later on another tour by way of Dulverton the two poets planned the Lyrical Ballads. For Wordsworth the landscape was the inspiration: for Coleridge the opium helped.

It was in a church mid-way between Lynton and Porlock that Lorna Doone was shot on her wedding day. Or so the novel says. It is a great story. Its hero is John Ridd, an Exmoor man of great stature and strength, whose father has been killed by the Doones, a family of robbers and murderers who inhabited a neighbouring valley.

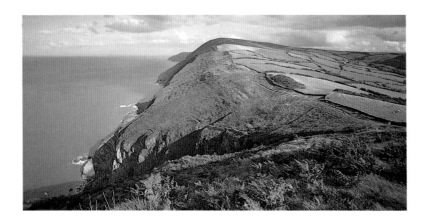

29. Great Hangman, Devon

John Ridd swears revenge but he is in love with Lorna, the daughter of the man who killed his father, so is Lorna good enough for him? Then it turns out that Lorna is really the daughter of a Scottish nobleman, so is John good enough for her? It all ends in tears.

It was a book which persuaded Anthony Eyton that he should accept the commission to paint in Exmoor. Not *Lorna Doone*, the Victorian novel, but a Victorian photograph album.

Eyton swears that he was at home sitting at the breakfast table when the photograph album fell from the bookshelf and fell open at a picture of Watersmeet. 'That,' he said, 'is the Sign; Exmoor it must be.'

When he got to Watersmeet he found it almost too good to be true – people splashing around, enjoying themselves. Most of Eyton's paintings have people in them and he would much rather go to a crowded beach than to an empty one (Pl 27). He finds it fascinating to look at people in their unguarded moments, when they are totally preoccupied with the landscape, the sea, or their children. They lose themselves.

He is interested in the effect the landscape has on them, especially if there is a storm. He loves, too, the contrast between the movement of the water and the stillness of the rocks (Pl 28).

He is less keen on moorland: 'those great saddles of moor,' as he puts it, 'are a bit like a desert.' Heather, he thinks, is a most difficult thing to paint and there is so much of it in Exmoor.

He motored miles, getting out at hedgerows, walking, trying to get a view that would capture its vastness.

In the end he settled for what he does best – painting a specific place. He selected Tarr Steps for he had also seen it in the photographic album. The 180 foot long clapper bridge with its seventeen spans is one of the finest examples of early man's attempts at bridge-building. It is the outstanding antiquity in Exmoor, though it has probably been rebuilt many times.

Tarr Steps, like Watersmeet, was busy when Eyton got there. It was, he says, a question of getting the balance right between the people and the Steps themselves. He thought the people very well-behaved, though a Park Ranger pointed out that there was a man cleaning his car with soap suds just out of picture.

Anthony Eyton thinks that play is an important aspect of life and is happy to have caught in his Exmoor paintings an aspect of mass tourism. He agrees with Geoffrey Camp who said: 'Happiness is rarely painted now.' Like Camp he is happy painting happiness.

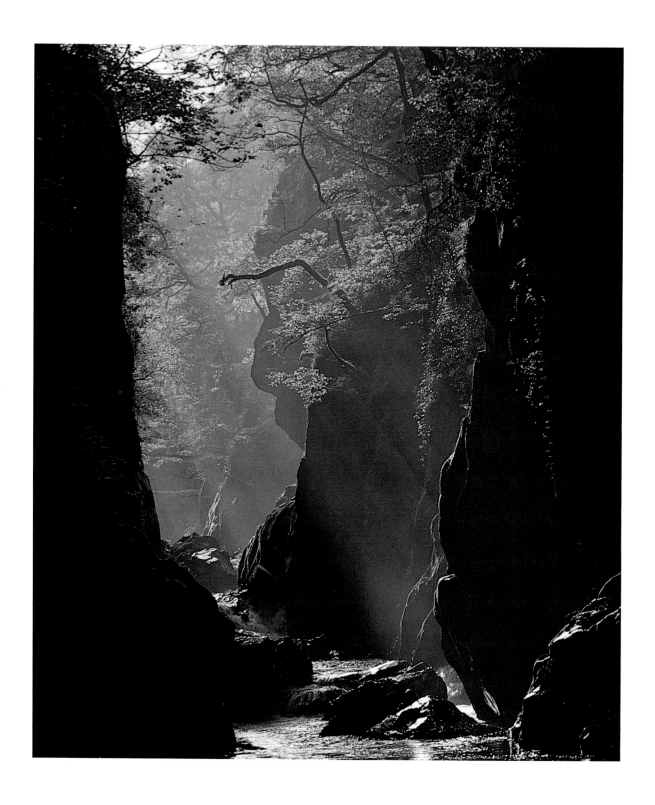

Snowdonia

Wordsworth climbed Snowdon, from Beddgelert to the summit, one night in 1791.

> *With forehead bent*
> *Earthward, as if in opposition set*
> *Against an enemy, I panted up*
> *With eager pace, and no less eager thoughts.*

When he looked up he found he had emerged above the mist which now lay below him lit up by the moon.

> *A hundred hills their dusky backs upheaved*
> *All over this still ocean, and beyond,*
> *Far, far beyond, the solid vapours stretched,*
> *In headlands, tongues, and promontory shapes,*
> *Into the main Atlantic.*

At his feet was a blue chasm, a rift ... 'A fixed, abysmal, gloomy, breathing-place,' from out of which

> *Mounted the roar of waters, torrents, streams*
> *Innumerable, roaring with one voice!*

This great spectacle became in his mind a symbol and an image of something even greater. The experience, as Mary Moorman says, was so haunting in its beauty and strangeness that it seemed to him fit to be made the climax of the story of his own poetic education, *The Prelude*.

Nature had offered him a perfect image of the creative imagination ceaselessly at work in the mysterious depths of the human mind. And for Wordsworth the highest bliss that could be known was this knowledge that man possessed in himself the very same

30. Fairy Glen, Gwynedd

creative faculty as Nature. Happiness for him was the fruit of this blessed power.

Fifty years later, on the eve of the publication of *The Prelude*, George Borrow went on a pilgrimage in Snowdonia. He too went on foot although the railway had by now been built. I am fond, he said, of the beauties of nature, and it is impossible to see the beauties of nature unless you walk.

He was likewise fond of poetry and he took special delight in inspecting the birthplace and the haunts of poets. He includes in his pilgrimage the poets Huw Morris and Goronwy Own, and the patriot Owen Glendower and his bard Olio Gooh.

He quoted from them at appropriate places – on Snowdon, and at Glendower's home at Sycharth, where he dismissed his guide to contemplate the lost past in solitude, and covering his face and his hands wept like a child.

His description of the view from the summit of Snowdon is not a patch on Wordsworth's.

Peaks, pinnacles and huge moels
stood up here and there, about
us and below us, partly in
glorious light, partly in deep
shade . . .

Though he had a nice unpoetic line about the waterfall of Pistyll Rhaeadr. 'It looked,' he said, 'like a strip of grey linen hanging over a crag.'

In a letter to Thomas Hughes, a year or two later, Charles Kingsley was more to the point.

Leave to Robert Browning
Beggars, fleas and vines;
Leave to squeamish Ruskin
Popish Apennines,
Dirty stones of Venice
And his gas-lamps seven;
We've the stones of Snowdon
And the lamps of heaven.

Gerard Manley Hopkins saw the beauty of Snowdon, but being a Jesuit as well as a poet, he could not leave well alone:

31. Christopher Le Brun.
Snowdonia.
Oil on canvas, 61 × 78.7 cm
(24 × 31 in). Private collection

'The mountain, is an archetype of a
mountain, something you're never
quite able to get to, something you're
always seeing through the veil of
trees. Held back – kept distant.'

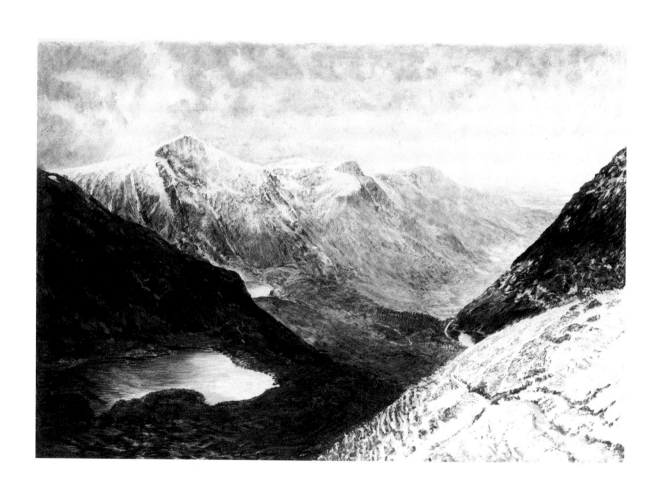

'The heights of Snowdon were hidden by the clouds but not from distance or dimness. The nearer hills, the other side of the Valley, shewed a hard and beautifully detached and glimmering brim against the light, which was lifting there. All the length of the valley the skyline of the hills was flowing written all along upon the sky. A blue bloom, a sort of meal, seemed to have spread upon the distant south, enclosed by a basin of hills. Looking all round but most in looking far up the valley I felt an instress and charm of Wales. Indeed in coming here I began to feel a desire to do something for the conversion of Wales ...'

In his sonnet, *In the Valley of the Elwy*, Hopkins made the same impertinent point.

Lovely the woods, waters, meadows, coombes, vales,
All the air things wear that build this world of Wales;
Only the inmate does not correspond ...

Snowdonia is very Welsh, but it is not there to be converted or conquered; it is there to be understood. Christopher Le Brun was living and working in Berlin when he received the commission to work in the National Park.

He drove all the way from Berlin to Snowdon non-stop and with every mile going west he was, he says, conscious of a growing freedom. He crossed the North Sea and just kept going west to Old Britain, as he put it, the Celtic Kingdom. He felt that he had come out of central Europe to the very edge of the continent.

During his visit to Snowdonia he stayed at the study centre at Tan-y-Ewlch. Welsh was spoken all around him. Indeed everyone but he spoke Welsh in the dining room.

The weather was misty and rainy and he became increasingly aware of the landscape as remote, secretive and hidden. It was, he says, almost impossible to see the top of Snowdonia. There was no view he could get of it. It was almost continually covered in mist. And the language, too, had about it something deliberately inaccessible.

That is his idea of Snowdonia and it is very similar to his idea of painting. You make a painting, he says, by covering things up; covering things that are light with dark. So his journey there, and his sense of place there, coincides with his idea about painting at the time.

When his visit was over he drove back to Berlin almost non-stop again all the way. He works from recollection and that means

32. Howard Bowcott.
Bochlwyd, Idwal, Ogwen and Nant Ffrancon from Bwlch Tryfan.
Pencil on paper, 94 × 152.4 cm (37 × 60 in). Private collection

'Cwm Idwal is a very popular spot with walkers and climbers. It is also a very important place geologically and there are lots of rare plants to be found at the top of the Cwm: even Charles Darwin came here. So it had all the elements I was looking for.'

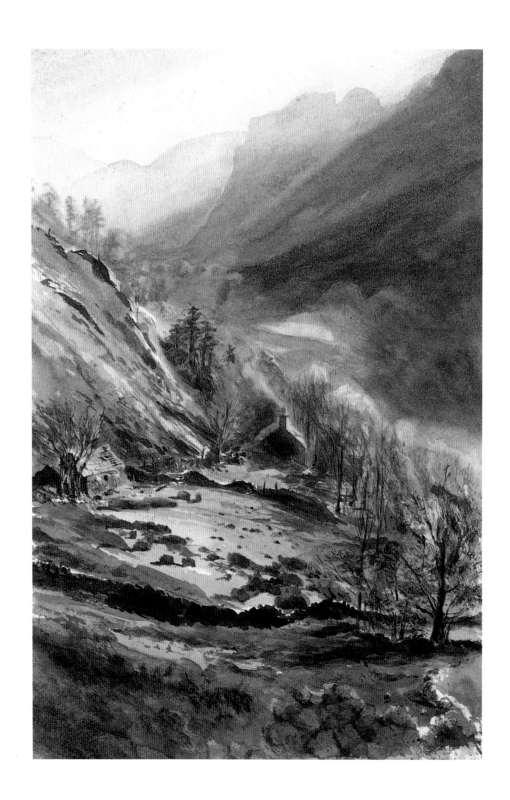

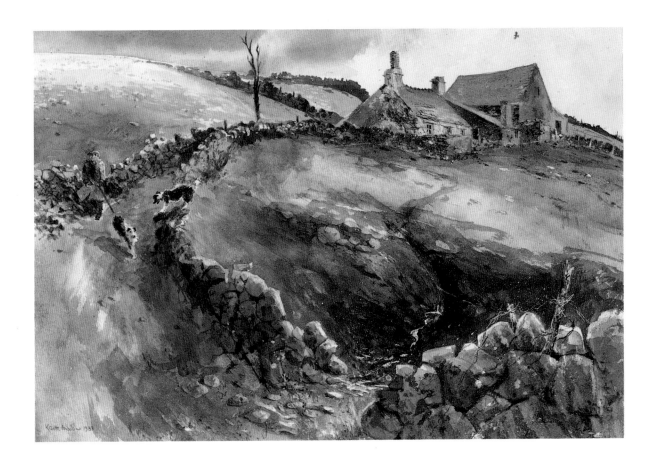

33. Keith Andrew.
From above Betws Garmon with Craig Cwmbychan in the distance.
Watercolour, 73.7 × 53.3 cm
(29 × 21 in). Private collection

'I was very lucky to get that light —
very often the weather and light
conditions here are so fleeting. But
fortunately it stayed long enough for
me to get something down on the
spot.'

34. Keith Andrew.
Farmer at Elidir Fach.
Watercolour, 55.9 × 73.7 cm
(22 × 29 in). Private collection

in a sense that he just has to wait until something happens in the studio.

His picture is not a picture of Snowdon, nor of any place, it is the sense of a hidden, secretive landscape (Pl 31). He finds it impossible just to depict a landscape. He is trying to find a parallel sense, painting what he feels, composing special relationships that are dependent on his experience, albeit through distant recollection.

The convention of painting is to paint a scene. But Le Brun views the business of painting as the manipulation of materials and substances to turn images into archetypes. He wants to create aspects of permanency, a completeness of form and shape. He paints the appearance of the idea rather than the appearance of the landscape.

It is a work of the imagination: he is recording an invisible object. The process is almost entirely intuitive. His painting consists of different pictures painted one on top of the other, with new pictures put on in every layer.

He wants to end up with an image that is an icon for the place, distanced from the temporary. It exists as a painting, a classical trope that defies time. 'Painting,' Le Brun says, 'keeps something safe, protected, preserved.'

He wants to make an ideal landscape. The trees in his painting of Snowdonia do not exist, except in the painting. The mountain is an archetype of a mountain, something you are never quite able to get to, something always seen through the veil of trees, something held back, kept distant.

The landscape of a country, he says, is like the soul of a country. If it is under threat, the whole country is under threat. Painting protects it.

For Howard Bowcott, Snowdonia is not remote, nor secretive, nor hidden. He lives in a tiny terraced house in Blaenau Ffestiniog and much of his work is about the slate quarries, and about man's relationship to the land through his activity and his quarrying.

In his picture for the Artists in National Park exhibition, Bowcott's idea was to capture what the Park means to him and to other people (Pl 32). And as he set to work, he began to realise that there are many ways of seeing the landscape and of responding to it.

He began to concentrate on these different responses and it took him into a new way of working. It also took him a long time to find the place that had all the characteristics of Snowdonia within it.

Normally he works directly in the landscape, but this time he worked from sketches and drawings and photographs. He interviewed

35. Clyde Holmes.
Craig Daw.
Oil on board, 83.8 × 104.1 cm (33 × 41 in). Private collection

'All the air things wear that built this world of Wales.'

a lot of people and wrote their comments around the edges of his drawings. The text works, he says, through the contrasted views of the landscape, and the best contrast is between the farmer and the climber.

All the farmer's words are Welsh. The Welsh names for the different parts of the hill that he finally chose as having everything that he finds sufficient to Snowdon, Cwm Idwal, all refer to historical events.

36. Rhinog Fach, Gwynedd

The Farmer
1,500 acres of mountain grazing, from the river to the skyline.

Llyn Bochlwyd	Cwm Cywion
Clogwyn Tarw	Cwm Cywion Bach
Cwm Cneifia	Cwm Côch
Cwn Oŵn	Gors Gôch
Cwm Idwal	Cefn Maes
Llyn Idwal	Ogof
Llwynbrau Caws	Ffrith
Y Garn	Pentre
Cestyll	Chernobyl
Cwm Clŷd	

Chernobyl is now a word in the Welsh landscape because many farmers still cannot sell their sheep as a result of the Chernobyl disaster.

The climber, a breed who only began coming to Snowdonia in the past century, has completely different names for the same places, and they are all aggressive, assertive, and English.

The Climber
Twenty Classic climbs in, above and out of Cwm Idwal.

Pinnacle Route	Homicide Wall
Suicide Wall	Subwall Climb
Holly Tree Wall	Rowan Tree Slabs Direct
Continuation Wall	Lazarus
Tennis Shoe	Javelin Blade
Capital Punishment	The Arête
Ordinary Route	Procrastination Cracks
Faith	Hanging Garden Gully
Hope	Devil's Pulpit
Charity	Devil's Kitchen

Howard Bowcott believes that Snowdonia is not simply a geographical area but layer upon layer of people's perceptions. He was fascinated, for instance, to interview RAF pilots who fly over Snowdonia in a few seconds. To them the lake is different shapes at different times of the year according to the rainfall, and in winter disappears altogether.

When he came to complete his drawing in his studio, he knew what was on the other side of the hill. And that is important to him. The hill is not simply a silhouette. It is a very dark piece of countryside, where he has been lost in the mist, and has fallen down the scree.

The landscape is a place of his memories and of the memories of others. He feels more involved in it now, more involved in the earth around him. But he is also very aware that our activities on the landscape are very ephemeral. 'When the slate works are abandoned, it is always the hearth that remains.'

The English, said Defoe, called Breckonshire not improperly Break-neckshire: 'Tis mountainous to an extremity.' Which is not wholly true, but then it is not wholly the business of the English.

The Brecon Beacons National Park stretches from the Black Mountains in the East, to the Black Mountain of the West, taking in the Brecon Beacons themselves, which rise to over 2,000 feet at Pen y Fan, and Fforest Fawr, which was once a Royal Hunting Forest.

These are the high red-brown sandstone hills which divide the ancient rocks of mid Wales from the South Wales coalfield. 7,000,000 people visit them every year and most of them come on day-trips from the Welsh valleys. It is their back garden.

Peter Prendergast was born in a coal mining valley in South Wales and he welcomed the commission to paint in the Brecon Beacons precisely because he regards it as part of his home, part of the same landscape. No coal mining valley, he says, is without streams and hills and within five minutes you can be completely away from the coal mining and in an isolated landscape.

He has spent twenty years painting in North Wales, mostly in Snowdonia. When he began painting there he felt conscious of the mountains being on top of him, as opposed to way in the distance. He tended to paint snippets of the landscape because he could never get completely back from it to see it properly.

In Brecon he felt immediately on top of the world, physically on top of the world. He was conscious of the feeling of space from where he was working to the actual mountain he was trying to draw. And the light was incredible, he says. The light changed all the time and it reminded him of the first paintings from the landscape he ever made as a child of thirteen or fourteen in South Wales. The thing that struck him was the light, which changed rapidly and was absolutely clear and crisp.

Henry Vaughan, who was brought up at Llangattock, and later made his home at Brecon, saw that light as a symbol.

37. Jennifer Durrant.
After L. F., 1987.
Acrylic on canvas, 304.8 × 365.8 cm
(120 × 144 in). Private collection

'A great ring of pure and endless light.'
Henry Vaughan.

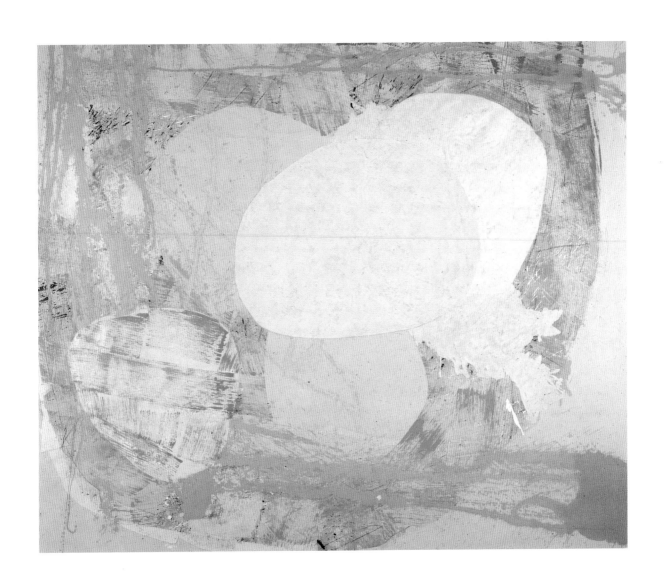

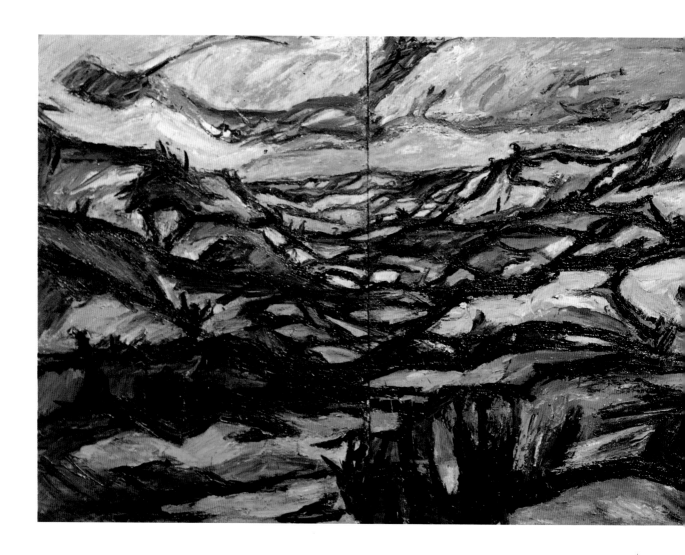

38. Peter Prendergast.
Above Tor-y-Foel.
Oil on panel, 134.6 × 348 cm
(53 × 137 in). Private collection

'Painting can't just be emotional. You
have to have a thought out structure.
I had to plan the design and
composition: the bones, and then use
these to hang the flesh on.'

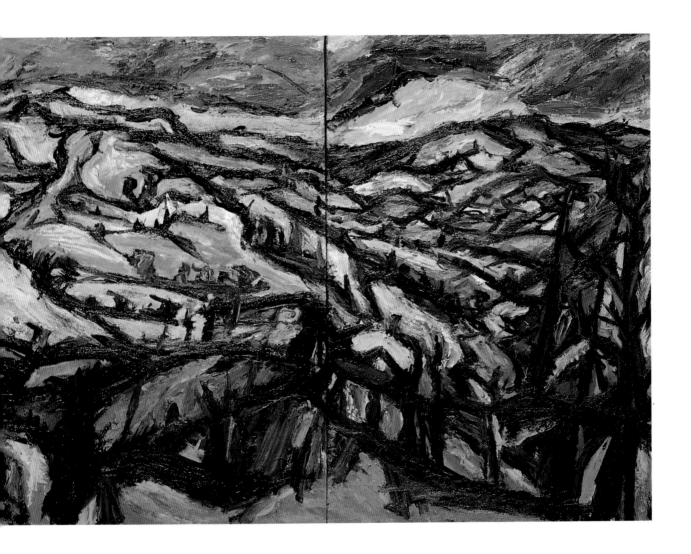

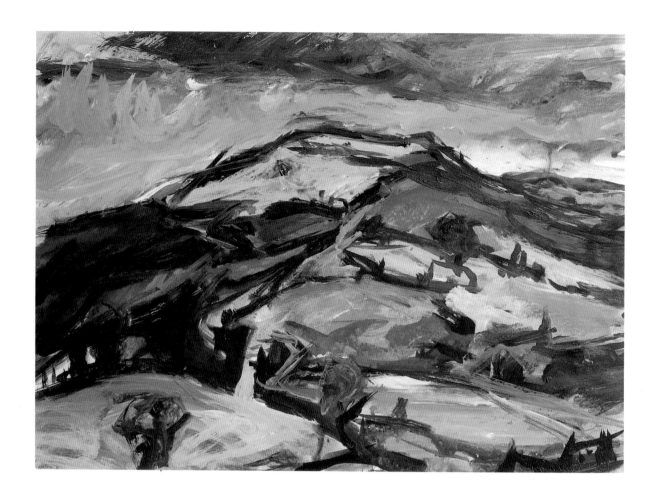

39. Peter Prendergast.
Study for *Above Tor-y-Foel*.
Acrylic on paper, 66 × 81.3 cm
(26 × 32 in). Private collection

'The drawings began to evolve into
an image that was about the
geography of the place, and the
geology – but also about the spirit of
it.'

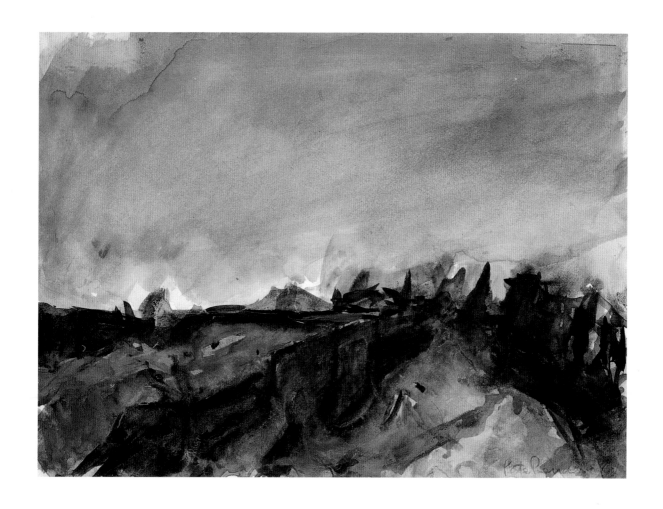

40. Peter Prendergast.
Study for *Above Tor-y Foel*.
Watercolour, 50.8 × 61 cm
(20 × 24 in). Private collection

I saw Eternity the other night,
Like a great ring of pure and endless light.

And for him the very stones of the Brecon Beacons were full
of praise for the Lord.

So hills and valleys into singing break,
And though poor stones have neither speech nor tongue,
While active winds and stream both run and speak,
Yet stones are deep in admiration.

When Peter Prendergast worked on the commission in Brecon
he set aside three months for making the preparatory drawings and
another three months to complete the painting. But where in Brecon
was he going to paint? Because, as he says himself, you could spend
all your life wandering around Brecon.

He did not want to paint the industrial part. He wanted to paint
something that was purely landscape and which related to his feelings
for South Wales. So he stayed in Brecon, looked at an ordnance
survey map, found a track that went to the top of a hill, drove up,
turned round ... and there was a marvellous view of the Brecon
Beacons looking towards the Usk.

He set about compiling small drawings there and then and some
very quick watercolours (Pl 40). He was trying to do them to capture
particular moments, changes in the weather, changes in the light, but
all as objectively as he could.

The drawings began to evolve into an image that was about
the geography of the place and the geology of the place, but also
about the spirit of the place. He began to let a lot of other things
come in to create a balance of the intuitive and the intellectual.

He wanted his painting to be a kind of symphony of that
landscape and he wanted a large landscape, a hill with a valley to the
left and to the right. And because of the way he works he knew it
would have to be three panels.

He was not interested in painting a pretty picture, what he was
trying to do was to take all that was there and remake it into
something which has all the strength and feeling of the place itself.
Something, as he put it himself, which can be taken away from the
hill and in ten or twenty years will stand up in its own right almost
as nature itself.

He looks upon paint as earth mixed with oil. Painting, he says,
is a committed activity and you have to want to make something.

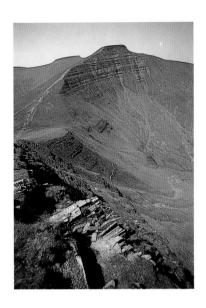

41. Pen y Fan, Monmouthshire

He tried to bring into the painting all his experience starting from when he was a boy in South Wales.

His father was a coal miner who spent most of his life underground and any spare moment he had he spent walking on the hills behind the valley showing his son everything. So although the painting is about the Brecon Beacons it is also a tribute to all Pendergast's early experience.

It is about his love of nature and landscape, he says, a celebration of being alive, a creaturely delight in being part of nature. He was trying to make the colour and the paint come alive on its own terms, as a real piece of nature (Pl 38).

Someone said about Turner that he knew more about the geology of the landscape than any geologist. Prendergast understands what that meant: that Turner did not draw the soil and the rocks beneath the grass.

He quotes David Bomberg, who said that what he was interested in was 'the spirit in the mass'. Beneath the earth and rock are all the answers to how the world was built.

That, Prendergast says, is what he is trying to do, to pierce beneath the skin of the earth to try to understand what is beneath. So beneath his painting are loads more drawings, loads more colour which has been painted over. The process continued until he arrived at what he was after – the ideal landscape. Picasso said that when a painter paints over a picture nothing is wasted, because the experience of what is covered over is there. It is like growing older.

His work, he says, is as much about pushing paint around as his father pushed coal around. He was brought up as a Catholic and a belief in making the most of your talents has coloured the way in which he has lived his life.

His happiest moments are working in the landscape and understanding it, not in any intellectual way, but by looking and touching. 'I have always felt,' he says, 'that if there is a God, He is somewhere in the mountains, somewhere in the earth.'

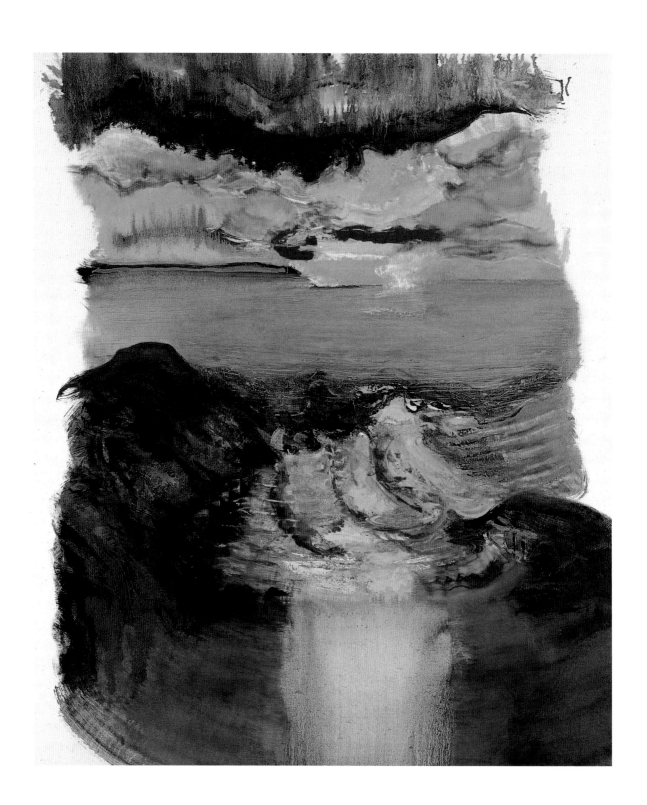

The National Park in Pembrokeshire is like no other National Park in England and Wales precisely because it is all coast. Only the Preseli Mountains, where the stones for Stonehenge came from, rise above it, and they are only little hills. The coastline is not so much the boundary of the Park as its definition. And the inland boundary is never far from the sea.

The path along this coast is one of the walks of the world. Other paths climb higher and plunge deeper, but none is more interesting every step of the way. To go to the Pembrokeshire Coast is not to get away from it all, but rather to be part of it all.

Over the centuries it has inspired faith and fury. It is rich in the recollection of saints and no fewer than 20,000 are said to be buried on Ramsey Island.

The last military force to invade Britain landed here at Strumble Head. It was a French force in 1797. They came hoping to rouse the peasants of Pembrokeshire to revolutionary fervour, but they upset the locals by commandeering a cargo of wine from a Portugese merchantman wrecked off the coast a month earlier.

The French invaders got irretrievably drunk and were seen off by the locals led by a woman called Jemima Nicholas. Twelve Frenchmen were killed, eight drowned, and one Welshwoman accidentally shot in the pub when a pistol went off.

Henry Tudor had better fortune when he landed by Mill Bay with 2,000 men in 1485. He marched his men the 176 miles to Bosworth Field in fourteen days and captured the Crown of England.

The most remarkable man to come from Pembrokeshire is said to have been Gerald of Wales, who was born in the Castle of Manorbier in 1145. He had everything going for him – noble birth, good looks, great energy, wide learning, moral passion, and even a sense of humour. Unfortunately he knew it. And so, although he came to know everyone who was anyone in his time – a Pope, Innocent III, three Kings, Henry II, Richard I, and John, and three

42. Maggi Hambling.
Pwll Deri: Sunset.
Oil on canvas, 155 × 132.1 cm
(61 × 52 in). Private collection

'This painting is my first big sunset. It's very important – I witness the event in watercolour. The watercolour is like taking it all in.'

Archbishops, Baldwin, Hubert Walter, and Stephen Langton – he rose no higher than Archdeacon of Brecon.

He wanted to be Bishop of St David's, but Henry II, who had had more than his fill with Becket, wanted no more turbulent priests. Gerald settled for the quiet life and wrote a fascinating book about Archbishop Baldwin's 'journey through Wales' to whip up support for the Third Crusade.

It is impossible to walk the Pembrokeshire Coastal Path without being aware of the history as well as the landscape. Sometimes the two seem to speak for each other. Beyond St David's Head there is a group of rocks called the Bishop and the Clerks, who, according to George Owen, writing around 1603: 'preach deadly doctrine to their winter audience, and are commendable in nothing but for their good residence. Nor are they without some small choristers, who show themselves at spring tides and calm seas.'

St David's Head is the site of an Iron Age fort and the stone-walled fields around there were marked out in the Iron Age too. Graham Sutherland, who loved painting in Pembrokeshire, once wrote that each field has 'a spear of rock at its centre. It is as if the solid rock foundation of the earth had thrown up these spears to transfix and hold the scanty earth of the fields upon it.'

Maggi Hambling went to Pembrokeshire in search of a sunset. She had been painting sunrises on the Suffolk coast and had mentioned to George Melly that she did not understand why the sunrises were so good in the east and the sunsets so good in the west. He looked at her and quietly explained that the sun rises in the east and sets in the west.

So off she went to Pembrokeshire. She got there on a Sunday afternoon in February and the sun set around five o'clock. It was, she says, a terrific sunset, and she hastily did three watercolours.

The next morning everything was covered in mist and she painted the water to go with the sunrise. She did this morning and night, sitting on exactly the same tussock in the freezing cold painting the sky at sunset and the water at sunrise (Pls 42 & 44). It was all happening very quickly. The sun set, the sun rose and she had to make haste otherwise it would all be over.

There is, she says, something joyous about a sunrise, a celebration of the day. But a sunset is the opposite of joyous, slower and sadder, though not as violent as a sunrise.

After she had completed her Sunset painting for the Artists in National Parks exhibition, she did not return to Pembrokeshire. Her next painting was a mixture of a sunset she saw in Venice and one

on the Pembrokeshire Coast. She called it *Mourning Sunset* and worked on it for two or three months before realizing it had to do with the death of her mother, who had died between her first and her final visit to Pembrokeshire.

The one after that she called *Drowning Sunset*. It was a mixture of imagination and her memory of one of the sunsets she had seen in Pembrokeshire when it seemed that the sun was hanging above the water, with bated breath, and then crashed down into the sea.

She called another painting inspired by the rocks she saw in the sea at Pembrokeshire *Mountain Walking out to Sea*. It was, she says, just like an animal going bouncing out.

Niamh Collins felt confused when she first went to Pembrokeshire. But she soon started falling in love with the place, particularly St David's Cathedral, where she was almost overcome by the combination of the bells ringing in the tower, a small boy filling the cathedral with organ music, a foghorn, and the large black cattle bellowing in the field next door.

But what she craved was space. The absence of figures in her landscapes is her reaction to an over-crowded Britain. On one of her

43. St. Govan's Head, Pembrokeshire

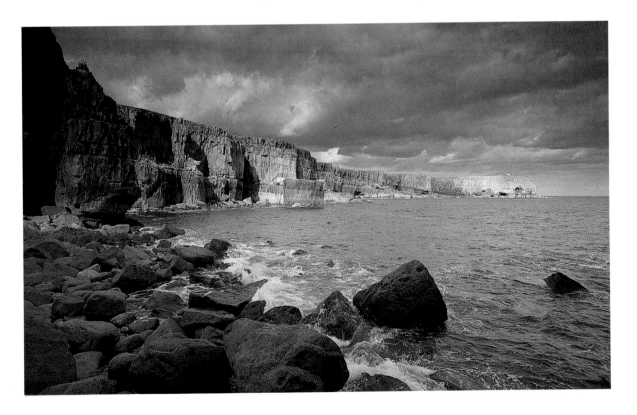

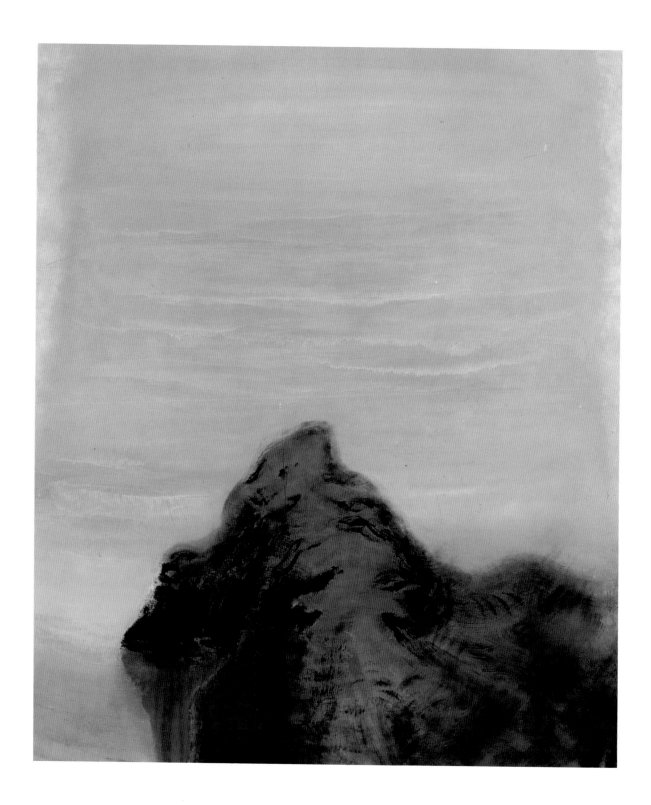

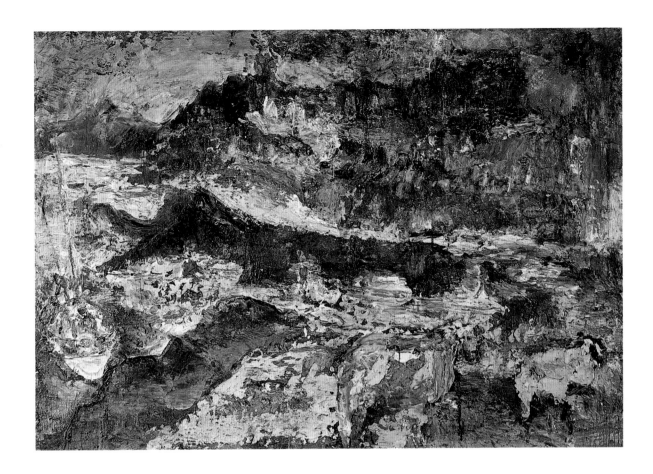

44 (*Left*). Maggi Hambling.
Pwll Deri: Sunrise. 22.2.88.
Watercolour, 71.1 × 61 cm
(28 × 24 in). Private collection

'Winter Sunrises can be quite
extraordinary, a lot of turquoises and
a lot of magenta – really something.
This darkness being shattered by the
light.'

45. Terry Setch.
Abereiddy.
Oil on canvas, 177.8 × 254 cm
(70 × 100 in). Private collection

To go to the Pembrokeshire Coast is
not to get away from it all, but rather
to be part of it all.

46 (*Overleaf*). Helen Chadwick.
Viral Landscapes Nos. 1 and 5.
Photographs, computer edited, each
106.7 × 304.8 cm (42 × 120 in).
Private collection

'There's something about the way
that water meets the land that has a
kind of erotic quality. Occasionally
the sea appears to be taking an active
role and occasionally it's reversed
when you get bays and promontories.
So you can't really say that one thing
is male and the other female.'

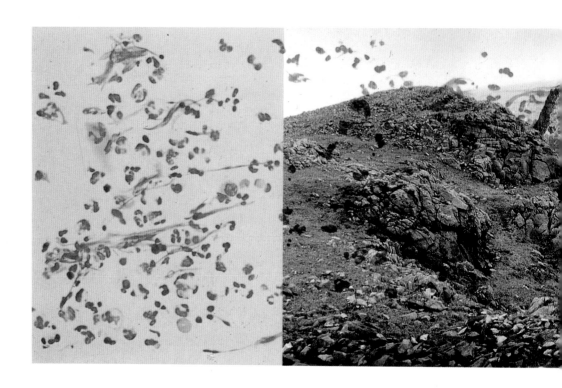

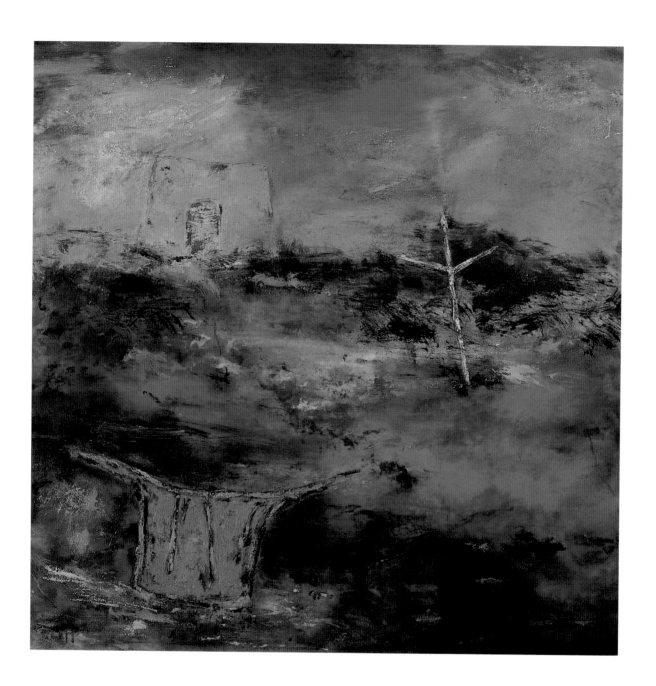

trips she walked along the cliffs near the Castlemartin Military Ranges. There was a very eerie silence. She could not hear the sea nor the wind, and she met no other people. And her imagination could not help associating this eerie silence with the military presence nearby, as if everything had been killed off.

She found herself, she says, yet again feeling very resentful of the way most beautiful parts of the country are being used for the nastiest purposes. The feeling of industrial decay too, elsewhere along the coast, was important to her, and she used man-made objects to comment on the fragility of man's influence.

Helen Chadwick, the artist commissioned to work in the Pembrokeshire Park, literally threw herself into her work. She wanted to do something at the Coast because it seems to her that where the sea meets the land is an area that is constantly shifting and changing, and that is a fitting metaphor for our subjective experience.

Being on the land looking down on the sea she felt as if she was in the space of body looking out at the space of subjectivity. When you look at the sea, she says, there is a sense that the specifics of your personality are being washed away. People identify this as relaxing or soothing. That state of consciousness interested her.

She began to feel the similarity between these slippages between our own boundaries and the boundaries of the sea and the land. Our state of consciousness takes us out of our body into rhythms that are fundamental and primary. The body is entering the landscape and the landscape is entering the body.

Traditionally we see ourselves as separate. She wanted to see what would happen if the distance was removed, so that everything was part of everything else.

She decided to mix three different elements. One was the image of the landscape, the conventional window. Another was the body, 'I wanted to go behind the flesh into tissues,' she says, ' and to present images of cells.' So she had her doctor and pathologist prepare slides of her own cells, and she photographed the ones that looked interesting. The third element was to allow the sea to create its own image, its own writing. To do that she made a series of wave paintings by throwing pigment onto the sea and letting the waves wash the pigment onto the canvasses.

With the help of a computer company, she then merged the three sets of images, using computer technology to control the emphasis given to each. She calls her works 'viral landscapes' (Pl 46) and that she says is crucial. If something enters something else at the level of cells is it is a viral condition.

47. Niamh Collins.
Solva Harbour.
Oil on canvas, 170.2 × 170.2 cm (67 × 67 in). Private collection

'The two man-made structures – the lime kiln and the mast – acted as a punctuation, a hard contrast the softness of the place, the water, the air and the sand.'

A virus is simply information, like the information inside a computer. It is not organic and it is not chemical. When it enters the body it is information which affects the cells and changes them.

'Human beings,' Hambling says, 'are nature's virus.' They enter the landscape, using and changing the natural world to the point at which there is no longer any natural world. Nature is just what there is, wherever there is. No one place, a National Park for instance, is any more natural than any other landscape. We have entered them all. The landscape is in a viral condition as we ourselves are.

She feels that we are all under threat – the body, the landscape, the sea. The idea of everything penetrating everything else could be transcendental, almost religious, but this is a scenario of pollution rather than of transcendence. She hopes her works are a contemporary response to the landscape, an understanding of it and of our relations with it.

Biographies

The Commissioned Artists.

Helen Chadwick
(*Pembrokeshire Coast*)

Born Croydon, 1953. Chadwick studied at Croydon College of Art, Brighton Polytechnic and the Chelsea School of Art from 1972–7. She lives in London.

Nominated for the 1987 Turner Prize.

Anthony Eyton RA
(*Exmoor*)

Born Middlesex, 1923. Eyton was educated at Camberwell School of Art and Crafts, has travelled very widely during his career and has worked in many parts of Britain. He now lives in London.

A member of the Royal Academy and associate of the Royal Watercolour Society, Eyton is a figurative painter, deeply rooted in the academic tradition but nonetheless capable of vivid personal expression. He has always been concerned with the actively inhabited space, with the human presence.

Andy Goldsworthy
(*Lake District*)

Born Cheshire, 1956. Goldsworthy studied at Bradford College of Art and Preston Polytechnic. He now lives near Thornhill in Dumfriesshire.

Goldsworthy works with natural materials, usually found near his home. The works are by nature ephemeral, and so are photographed by the artist. The photographs are exhibited in the hope that others may experience his ideas when outdoors. His work naturally changes with the seasons – in winter, for example, he often uses ice.

He has a particular affinity with the Lake District, having lived in Cumbria for several years. He also worked very successfully on the Grizedale Forest scheme.

Peter Greenham RA
(*Northumberland*)

Born London, 1909. Greenham is married to the artist Jane Dowling and lives in Oxfordshire.

He attended the Byam Shaw School of Art from 1936–9, was elected an Associate of the Royal Academy in 1951 and in 1954 started teaching at the Royal Academy Schools. In 1960 he was elected a full member of the Royal Academy, and Keeper in 1964. He has written for *The Scotsman* and *The Times Literary Supplement*, and in 1969 published a study of Velazquez.

Christopher Le Brun
(*Snowdonia*)

Born Portsmouth, 1951. Le Brun studied at the Slade School of Fine Art and the Chelsea School of Art from 1970–5. He has exhibited widely in Britain and Europe, and his work is held in public collections around the world.

Le Brun is a figurative painter who draws from the romantic-classical tradition, and his pictures derive their energy from the power of mythology.

Richard Long
(*Dartmoor*)

Born Bristol, 1945. Long studied at St Martin's School of Art, but still lives and works in Bristol.

He held his first one man exhibition in 1968 in Dusseldorf and since then has exhibited at major venues throughout the world.

Nominated for the 1987 Turner Prize.

Garry Fabian Miller
(*Yorkshire Dales*)

Born Bristol, 1957. Fabian Miller now lives in South Devon. He derives his images from gathering natural materials, and passing light through them on to Cibachrome paper. He directs us to look at the basic elements which compose the landscape, such as leaves, reeds and seed pods, and

through their mutability shows us the changes and cycles of time integral to place.

David Nash
(*Peak District*)

Born Esher, 1947. Nash lives in Blaenau Ffestiniog, Wales, and studied sculpture at Kingston College of Art.

His usual material is wood, both living and felled. He has a strong sense of the material's location and nature.

In 1978 he was one of the early artists in residence in the Northern Arts' Grizedale Forest scheme, and in 1981 he was a Yorkshire Sculpture Park Fellow. He has also worked very successfully in Japan, Holland and the United States.

Peter Prendergast
(*Brecon Beacons*)

Born Abertridwr, South Wales, 1946. Now living in Bangor Prendergast studied at the Slade School of Fine Art. At the Slade he was influenced by the teaching of Frank Auerbach to work from a direct visual approach through experience, rather than from theory. He has a particularly strong feeling for the Welsh landscape and his work has been widely exhibited throughout England and Wales.

Len Tabner
(*North York Moors*)

Born Southbank on the River Tees, 1946. Tabner lives in the coastal village of Boulby within the North York Moors National Park. He studied at Middlesborough, Bath and Reading.

Tabner's work is deeply rooted in the local landscape and he has a particular fascination with the coastline and the sea.

Biographical Notes: The Invited Artists.

Keith Andrew
(*Snowdonia*)

Born 1947. Andrew attended Ravensbourne College of Art, and lives in Anglesey. He is a traditional watercolour artist.

Adrian Berg
(*Lake District*)

Born 1929. Berg attended St. Martin's School of Art and the Royal College of Art and taught drawing and painting at the Central School of Art and the Camberwell School of Art. He lives in Hove and is a modern figurative painter.

Howard Bowcott
(*Snowdonia*)

Born 1956. Bowcott holds a degree in the fine art from the University of Newcastle and lives in Snowdonia National Park. He is a sculptor and draughtsman with a particular interest in the relationship of people to the landscape.

Niamh Collins
(*Pembrokeshire Coast*)

Born 1956. Collins lives in London and studied at Portsmouth Polytechnic and the Royal College of Art. She is an abstract painter.

Julian Cooper
(*Lake District*)

Born 1947. The third generation of a family of Lake District watercolour artists, Cooper studied at Lancaster Art College and Goldsmiths College. A figurative painter, he lives and works in the Lake District.

Jennifer Durrant
(*Brecon Beacons*)

Born 1942. Durrant attended the Brighton College of Art and the Slade School of Art. She is an abstract painter and uses glazed acrylic paint built up in layers on canvas. She lives and works in London.

James Faure Walker
(*Exmoor*)

Born 1948. Faure Walker studied at St. Martin's School of Art and the Royal College of Art and is a former editor of the *Artscribe* fine art magazine. He lives in London and is an abstract artist.

Maggi Hambling
(*Pembrokeshire Coast*)

Born 1945. Hambling studied at the

Ipswich, Camberwell and Slade Schools of Art and was the first artist in residence at the National Gallery in London. A recurring theme of her work is sunrise and sunset. She lives in London.

Clyde Holmes
(*Snowdonia*)

Born 1940. Holmes is a poet as well as a painter, and emphasises nature and the landscape in his works.

Eileen Lawrence
(*Peak District*)

Born 1946, Lawrence studied at the Edinburgh College of Art. She paints in watercolour on handmade paper, and incorporates natural materials into her works. She lives in Edinburgh.

Simon Lewty
(*Dartmoor*)

Born 1941. Lewty studied at the Mid Warwickshire School of Art and the Hornsey College of Art. His works depict visionary landscapes, in the manner of old maps and texts. He lives in Leamington Spa.

John Morley
(*Brecon Beacons*)

Born 1943. Morley studied at the Beckenham Art School and the Royal Academy. He specializes in still-life

and landscapes, and uses both oil and watercolour. He lives in Suffolk.

Brendan Neiland
(*Dartmoor*)

Born 1941. Neiland attended the Birmingham College of Art and the Royal College of Art. He works chiefly using sprayed acrylic, and lives in London.

Roger Palmer
(*Lake District*)

Born 1946. Palmer teaches at Glasgow School of Art. He is a conceptual artist who uses photography and recently won the Photographers Gallery Award for best photographic publication for his work on precious metals. He lives in Glasgow.

Anthony Rossiter
(*Lake District*)

Born 1926. Educated at Eton and Chelsea Polytechnic, Rossiter is a figurative painter whose style has been likened to Van Gogh and Edward Munch. The author of two award-winning autobiographies, he lives near Bath.

Terry Setch
(*Pembrokeshire Coast*)

Born 1936. Setch studied at the Sutton and Cheam School of Art and the

Slade School of Art. He is a senior lecturer at Cardiff College of Art and paints in the abstract landscape tradition.

Keir Smith
(*Lake District*)

Born 1950. Smith studied at Newcastle University and the Chelsea School of Art. He is a carver working mostly in wood and occasionally in stone, and lives in London.

Richard Sorrell
(*North York Moors*)

Born 1948. Sorrell attended Kingston College of Art and the Royal Academy. He paints in watercolour, oil and acrylic, and lives in Norfolk.

Kerry Trengove
(*Dartmoor*)

Born 1946. Trengove got to know Dartmoor as a child. He works in relief – the borderline between painting and sculpture – and much of his work depicts barriers and boundaries. He lives in London.

Karl Weschke
(*Yorkshire Dales*)

Born 1925. Weschke is a self-taught metaphorical or figurative painter. He has lived in Cornwall for more than thirty years.

Index